IMAGES
of America

SALEM TOWNSHIP
AND DELMONT

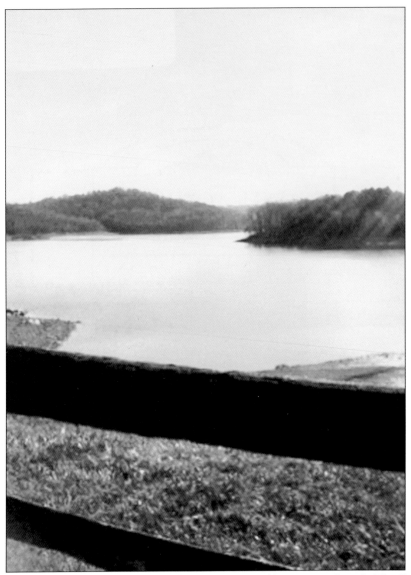

The borough and villages of Salem Township are connected by water and roads. The Beaver Run Reservoir, with a capacity of 11 billion gallons, was constructed in 1952 and enlarged in 1962. A "Big Spring" is located in Delmont. At one time, water from the Big Spring flowed into a watering trough in the center of town. In the 1970s, the trough was disconnected from the Big Spring and water was redirected into the Beaver Run Dam. The Beaver Run Reservoir supplies water to most of Westmoreland County and Salem Township. (Courtesy of Tracy Searight.)

ON THE COVER: Delmont would never have become a major stagecoach stop without the constant stream of water from the Big Spring that flowed into the water trough. Located in the center of town, the trough is a popular spot in this 1910 picture. (Courtesy of Lysle Bash.)

IMAGES
of America

SALEM TOWNSHIP AND DELMONT

Tracy Searight

ARCADIA
PUBLISHING

Published by Arcadia Publishing
Charleston, South Carolina

Printed in the United States of America

Library of Congress Control Number: 2012936285

For all general information, please contact Arcadia Publishing:
Telephone 843-853-2070
Fax 843-853-0044
E-mail sales@arcadiapublishing.com
For customer service and orders:
Toll-Free 1-888-313-2665

Visit us on the Internet at www.arcadiapublishing.com

For my four wonderful children—Brittany, Michael, Jenny, and Jessica

CONTENTS

ACKNOWLEDGMENTS

Salem Township includes so many villages, and I did my best to include as many of them as I could in this book. In conducting research for this book, I have realized how important it is to take pictures for future generations. It is so easy to take something for granted, only to realize one day that it is simply no longer there. Many years ago, one man, W.J. Zimmerman, saw in Delmont the potential of its history and kept a written record that spanned over seven decades, until his death in 1960 at 100 years old. I have great appreciation for the time and effort that he put into collecting newspaper articles and recording daily events in Delmont. Without his determination and consistency, a part of Delmont's history would remain unwritten. Also, I want to thank Robert Yaley, his grandson, who has been the guardian of his scrapbooks, for allowing the community to take a peek into Delmont's past. I want to especially thank Bob Cupp, who penned, for Delmont Borough, *A Valley in the Hills*. His kindness and generosity in helping me with my research has been as invaluable to me as his grandmother's scrapbooks. I would like to thank Raymond A. Washlask for the use of his collection of photographs; Raymond Meehan for sharing his collection; and Leslie Tsouris for allowing me to tour her beautiful home, which once belonged to Jacob Earnest. I want to thank all of the residents who contributed in some way or another to this book. I also wish to thank my acquisitions editor at Arcadia Publishing, Abby Henry, for all of her guidance and support with my book. I especially want to thank my children and my husband, who endured my many hours of research for this book.

INTRODUCTION

Salem Township and Delmont begins with the arrival of coal companies that descended on the rural county of Salem Township to exploit mines and create coal patch communities. In the last quarter of the 19th century, parts of Westmoreland County harbored large deposits of bituminous coal. Providing a source of continuous coal veins no less than seven feet in thickness, the so-called Pittsburgh coal seam runs through Salem Township.

In the late 1800s, commuting from towns and cities to isolated mining operations was almost impossible, so mining towns were built to attract and keep workers. The key companies in this area were Jamison Coal & Coke and Keystone Coal & Coke, the latter so named due to the main line of the Pennsylvania Railroad running through it. The Pennsylvania Railroad built spur tracks for transportation between the communities and the large commercial centers.

Salem Township is made up of the borough of Delmont and several small villages, which include Congruity, Crabtree, Five Points, Forbes Road, Frogtown, Greenwald, Highland, Huron, Patton, Salemville, Shieldsburg, Slickville, and Trees Mills. Coal companies were located in Huron, Salemville, Forbes Road, Patton, and Huron. Coal patch communities were Crabtree, Forbes Road, and Slickville. In 1917, Slickville was the last coal patch community developed in Westmoreland County. The 1930s saw a decline in the demand for soft coal, and some companies, such as Jamison's holdings, closed. Over time, the decline continued, the companies eventually closed, and the coal patch communities were abandoned.

Delmont was a desirable location due to the presence of a "Big Spring." In 1810, Thomas Bigham devised a way to transport water from the spring to the center of town by laying down the first wooden water line from the spring that emptied into a wooden water trough. The water trough has changed in appearance over the years and, although not in use today, a 1973 reconstructed version remains on East Pittsburgh Street.

Delmont has endured several name changes and has a unique history due to the fact that the town's name did not reflect the name of the town's post office until 1967. In 1784, William Wilson was warranted 300 acres of land in Salem Township. The name New Salem was chosen since Wilson arrived from Salem, Massachusetts. He lived on his 300-acre farm until his death in 1796. After Wilson's death, his two sons, George and Thomas, inherited the farm, but they did not perfect the patent until 1812. Over the next two years, George, his six sisters, and two of their husbands all conveyed their deeds over to Thomas.

As sole owner, Thomas Wilson laid out 48 lots to form a "crossroads" town and auctioned them off two days before Christmas 1814. Even though the area had been known as New Salem since 1784, the post office was established as Salem X Roads on November 7, 1812. The area became popularly known as Salem Crossroads. Although the town was incorporated as New Salem Borough in 1833, the town's post office continued to be called Salem X Roads until 1871.

Zachariah Zimmerman, the town's druggist and postmaster, felt the term *crossroads* handicapped the town, and he found that mail was being mistakenly delivered to New Salem in Fayette County

in addition to other communities in Pennsylvania that included Salem as part of their name. On May 23, 1871, Zimmerman changed the name of the post office to Delmont. The name Delmont has traditionally been said to mean "a valley in the hills." The town continued as New Salem Borough despite the post office being Delmont. It was not until 96 years later—in 1967—that the name of the town was officially changed to Delmont. Even today, a few businesses use Salem or Salem Crossroads.

During the 1800s, New Salem (Delmont) was the last stagecoach stop before Pittsburgh and boasted as many as five stagecoach lines at one time. This was due to the North-South Road, from the Poke Run Church to Greensburg, later known as the Greensburg Road, which was built through the village around 1800. In 1819, the East-West Northern Turnpike (which later became William Penn Highway) linking Pittsburgh to Philadelphia was completed. The turnpike passed through Salem Crossroads, bisecting the North-South Road at the center of town, where Greensburg Road and East-West Pittsburgh Street intersect. In 1853, the Pennsylvania Railroad was completed, leaving little need for a stagecoach town.

Delmont continued to survive, however, as growth came with the development of roads. On December 9, 1993, Amos K. Hutchinson Bypass (Pennsylvania Turnpike 66) was completed just south of Delmont in New Salem Township. Every October, And Delmont hosts the Apple 'N Arts Festival, which receives between 30,000 to 40,000 visitors, and another 6,000 people arrive each December for the Christmas in Salem Crossroads Pilgrimage.

One

COAL AND PATCH COMMUNITIES

The 1867 atlas of Salem Township consists of boroughs and villages, many of them never incorporated. Due to a majority of the township being underlaid with continuous veins of coal, the most enterprising industry in Salem Township was coal mining. With veins no less than seven feet in thickness, the supply is almost inexhaustible. This made Salem Township a desirable area for companies to develop and establish Appalachian mines and coal patch communities. (Courtesy of Westmoreland Historical Society.)

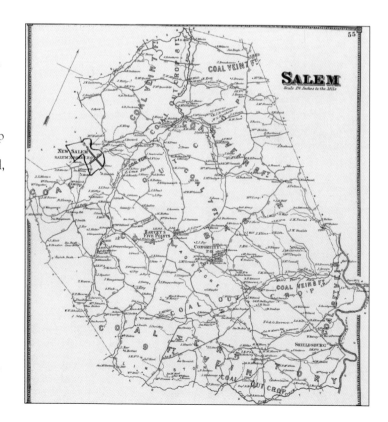

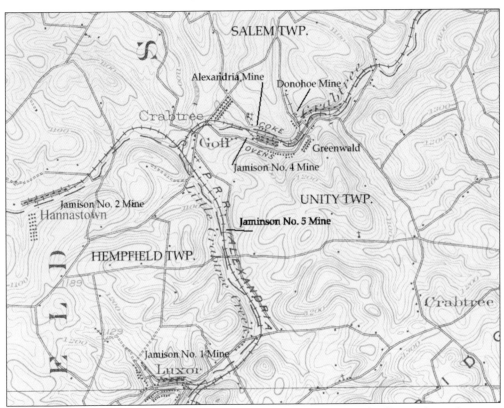

A c. 1902 USGS Latrobe (Pennsylvania) quadrangle map shows the various mines and townships. As seen here, sections of Crabtree are located within three townships—Salem, Hempfield, and Unity. (Courtesy of the US Geological Survey, Washington, DC.)

In 1915, men from Cambria Steel Company (later part of Bethlehem Steel) came to Salem Township and surveyed the area. It was common in the Appalachian mining communities to name a locale after a mining official. The Cambria Steel Company mining official at the time was Donald Slick. In 1917, therefore, the town of Slickville was founded. (Courtesy of Tracy Searight.)

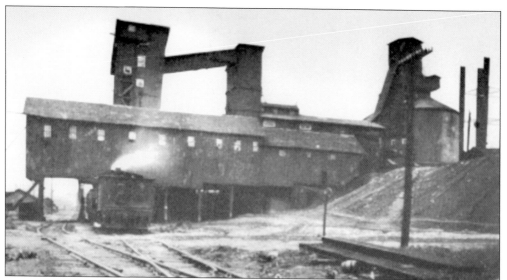

This is a c. 1930s postcard of the Salem No. 1 Mine of the Keystone Coal & Coke Company of Salemville, Pennsylvania. Shown here are the tipple, concrete coal-holding hoppers, rail yards, and the coal washer plant. On the right side of this picture are smokestacks from the electric power and steam generation plant. (Courtesy of Peter E. Starry Jr.)

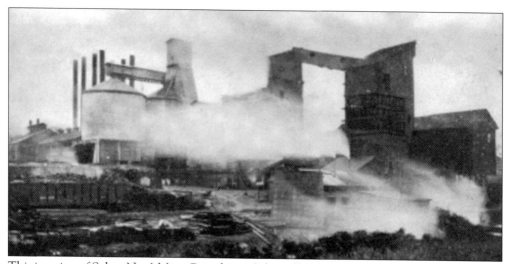

This is a view of Salem No. 1 Mine Complex in Salemville (owned by the Keystone Coal & Coke Company) at the height of production in the 1930s. At left in the photograph are coke ovens and railcar loading tracks; in the background is the electric power and steam generating plant. Behind the coal washer plant are the large concrete hoppers. (Courtesy of Peter E. Starry Jr.)

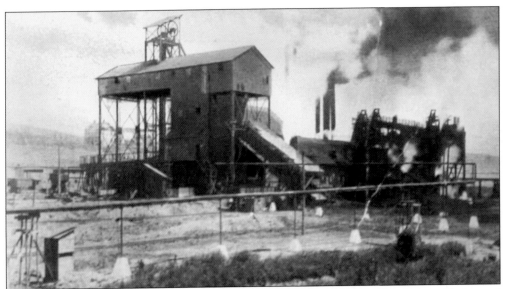

Here is a 1920s view of the Salem No. 1 Mine's coal washer plant and tipple at Salemville (owned by Keystone Coal & Coke Company, based in Greensburg, Pennsylvania) during the peak production level. Among the mine complex's facilities pictured here are the washer plant, tipple, coal storage bins, coal washer plant, steam generating plant, machine shops, electric generating plant, railroad yard, and coking facility. (Courtesy of Peter E. Starry Jr.)

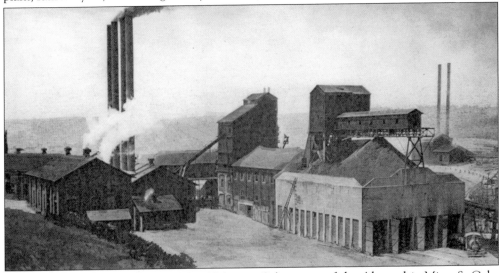

This postcard shows the Jamison No. 4 Mine in Salem, part of the Alexandria Mine & Coke Works, which operated from 1885 until the 1930s. In 1788, a tract of land that is now Crabtree was given to James Westley by the Commonwealth of Pennsylvania. The town was originally called "The Jest" and "Goff" until its name was changed to Crabtree. It is considered a census-designated place. In 1884, Thomas Donohue started the Alexandria Coal Company. The Pennsylvania Railroad built a rail line for the purpose of transporting coal and coke. On the Salem Township side, a railroad station was built. By 1890, there were 500 people living in Crabtree. A town hall was built by the coal company, which also constructed and owned houses for its workers. In 1901, the Alexandria Company sold out to Jamison Coal Company and more houses were built until the company closed. (Courtesy of Tracy Searight.)

This is an aerial view of the Salem No. 1 Mine after production ceased around 1960. In the upper left corner are both the new US Route 22 and the old US Route 22. The photograph shows the boney dump, company store, bosses' row, two rows of coke ovens, the tipple, and a part of the Salemville patch. (Courtesy of Danny Speal and the New Alexandria Bicentennial History Committee.)

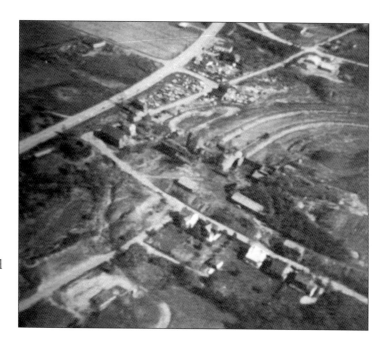

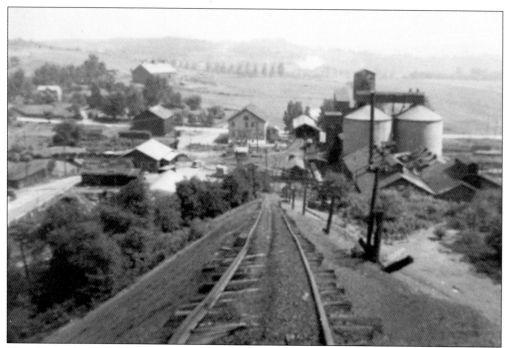

This 1940s photograph is from the top of the slate dump (boney dump) of Salem No. 1 Mine of the Keystone Coal & Coke Company. Various company buildings can be seen, including the company store and the superintendent's house across old US Route 22. Located in the center background, behind the row of pine trees, is the Huron Mines & Coke Works. (Courtesy of Peter E. Starry Jr.)

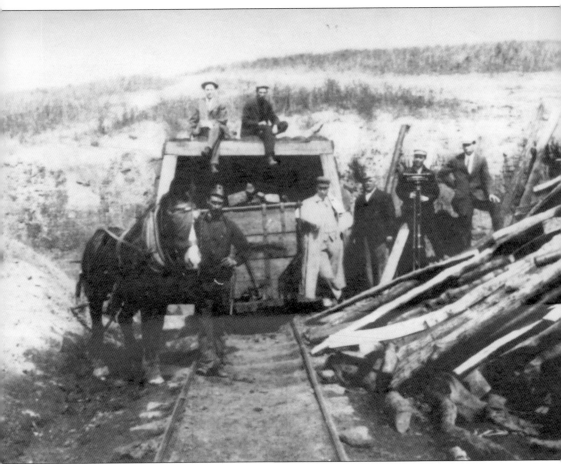

Coal miners, like those in this 1907 photograph at a mine near Salem Township, were accustomed to long hours in dark mines that averaged three to five feet in width. This meant that miners worked all day standing upright and had little ventilation from the dust they were exposed too. Since the companies were seeking a profit, miners were left to deal with using old or outdated tools and carts. Once the coal was depleted, the operation closed and moved on. During its peak production, Jamison Coal & Coke employed 2,503 workers and generated more than 3.2 million tons of coal. Keystone Coal & Coke produced 1.6 million tons and had 1,499 employees during its peak production. (Courtesy of Tracy Searight.)

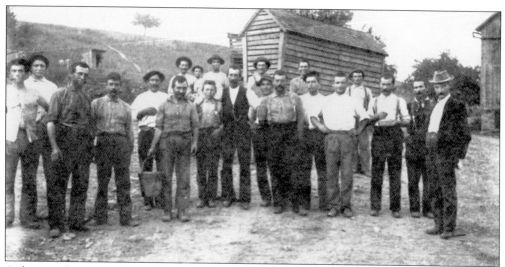

A day's work is never done, but the men find time to relax for a bit. This group of coal miners stops to pose for the photographer in 1907. (Courtesy of Tracy Searight.)

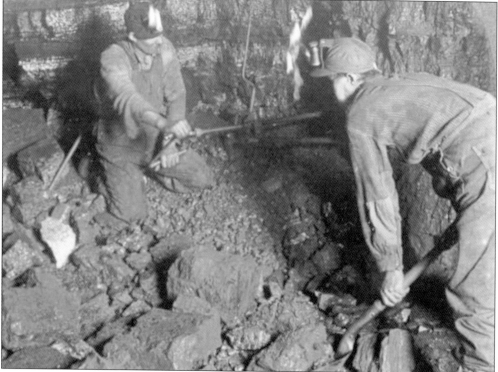

These miners are shoveling and drilling for a blast in western Pennsylvania in 1910. Coal miners had a long day of work, especially when they labored in coal seams that were several feet thick. A miner would spend hours hunched over or lying on his side in a narrow seam. Prior to mechanization, miners used hand tools and explosives. A skilled laborer would work for hours with a pick and wedge to remove the coal, all the while hoping it would not shatter. If the miner was unable to dislodge the coal by hand, holes were drilled into the rock surface and explosives were placed in the holes. (Courtesy of Tracy Searight.)

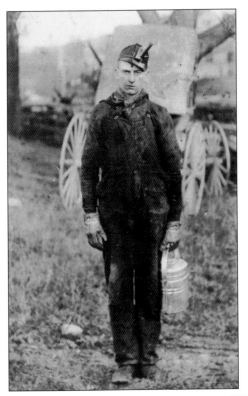

Coal was originally mined by pick and shovel. Early miners wore soft hats with open-flame carbide lamps to provide light. Eventually, this method gave way to battery-powered lamps. The miners' clothes and boots as well as all household needs were purchased at the company store. (Courtesy of Tracy Searight.)

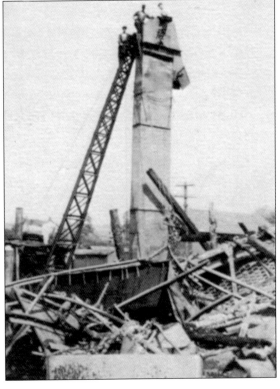

Fire again struck Keystone's Salem No.1 Mine coal processing plant in September 1930. Shown here atop the rubble are, from left to right, Frank Shearer, Bob Sheffler, and Bill Nesbit. (Courtesy of Bob Sheffler and the New Alexandria Bicentennial History Committee.)

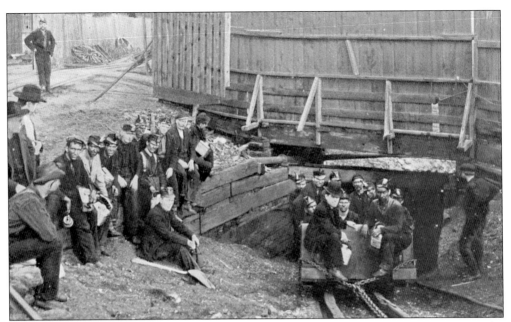

A part of daily life in a coal mining community is depicted in this postcard dated 1907. The miners are coming out of a coal shaft. Mines in Slickville were supported by pit-posts. Miners dug the coal and loaded it onto a coal car, which was pulled out to the tipple by horses or mules. (Courtesy of Tracy Searight.)

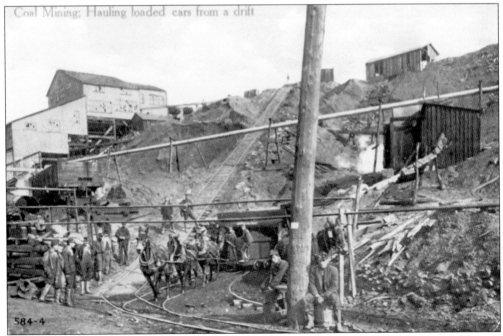

The miners would pack the car with coal and haul it from the drift. In this photograph, mules are used to transport the loaded coal from the drift. The coal was dumped into hoppers at the tipple and was then loaded onto railroad coal cars. (Courtesy of Tracy Searight.)

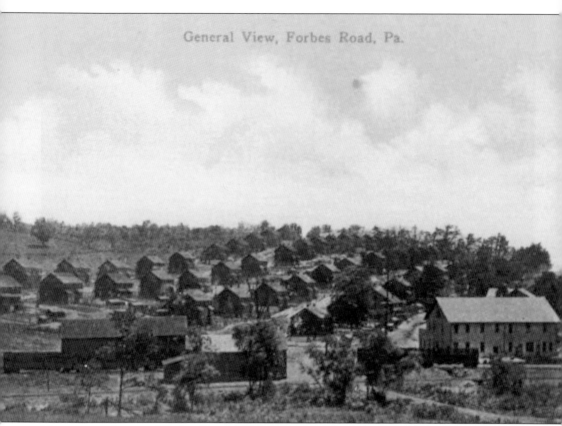

This a general view of Forbes Road. The miners of Jamison Coal & Coke Company's No. 3 coal mine and coke ovens were at one time housed at the Forbes Road patch. (Courtesy of Tracy Searight.)

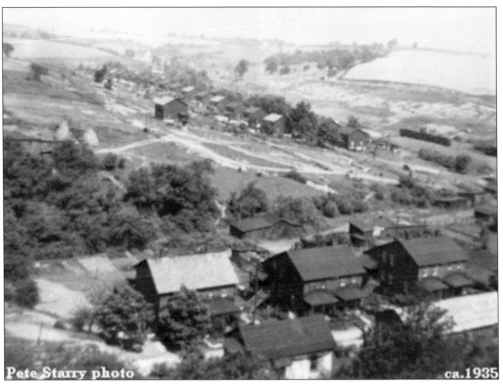

Pete Starry photo ca.1935

This photograph of Salemville patch around 1935 shows the bosses' row in the foreground and two rows of workers' houses in the background. Salemville was a company-owned village, one of a few in Westmoreland County. The area was surrounded by a fence as a symbol of the company's authority over each man and his family. (Courtesy of Pete Starry.)

The process of burning coal for production involved many stages. At this point, to prevent the coke from burning up too quickly, the door was closed and the charge left to burn from 48 to 72 hours. The coke was then drenched in water before removal from the oven. Watering took up to an hour to complete. (Courtesy of *Focus* magazine, the *Tribune-Review*, Greensburg, Pennsylvania.)

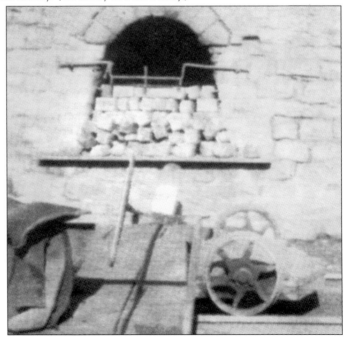

Workers used a variety of tools when dealing with coal to help sift out impurities and to keep from crushing the coke. This is a picture of some of the various implements used in Salemville by the miners and coke workers. The large pitchfork was used to shovel the coke. (Courtesy of *Focus* magazine, the *Tribune-Review*, Greensburg, Pennsylvania.)

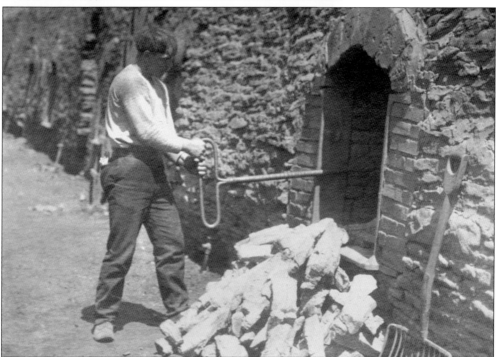

This photograph of a coke worker loading up the coke oven, though not located in Salem Township, provides a good view of the process. (Courtesy of Rhys Yeakley.)

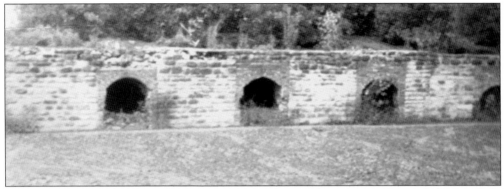

Most of the beehive ovens were built before 1918 and typically constructed into a hillside to help insulate them so they would retain their heat after firing for the next batch of coal. The banks of an oven were called a battery. Throughout the western Pennsylvania coal region, there are many examples of banks of abandoned beehive coke ovens. (Courtesy of Pete Starry.)

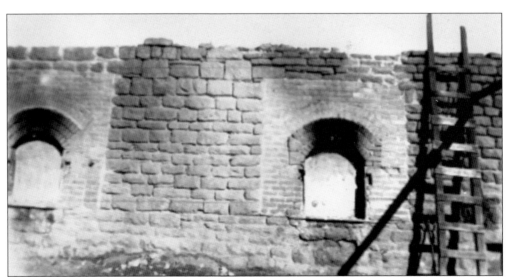

This 1947 photograph shows the abandoned Salemville coke ovens of the Keystone Coal & Coke Company. Called beehive ovens, they were located at the slate dump, Salem No. 1 Mine. The beehive oven gets its name from its domed, beehive-like shape. These were masonry domes constructed in long rows for loading and uploading. The coal was brought by workers from nearby mines and dumped through openings in the tops of the ovens. The top was sealed, and the oven almost completely shut. The coal was then ignited and smoldered. (Courtesy of Pete Starry.)

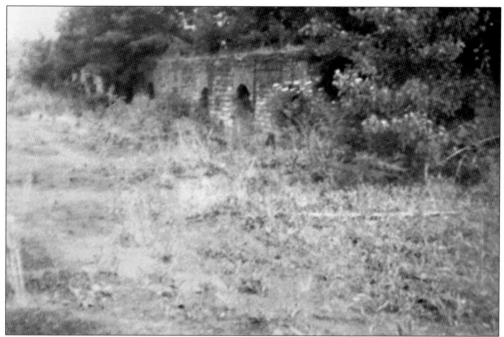

This photograph shows the Coke Oven Battery at Salem No. 1 Mine after abandonment in the 1960s. (Courtesy of Peter E. Starry Jr..)

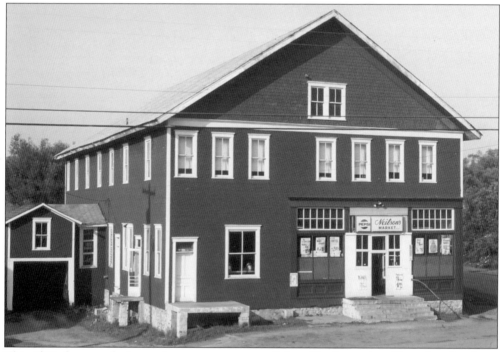

This 1977 photograph shows the company store at Salemville, located on Township Road just off of the new US Route 22. Originally, this was the Hempfield Supply Company No. 4 and was located on the old US Route 22. Asphalt siding covers the original clapboard exterior. (Courtesy of Fred Yenerall.)

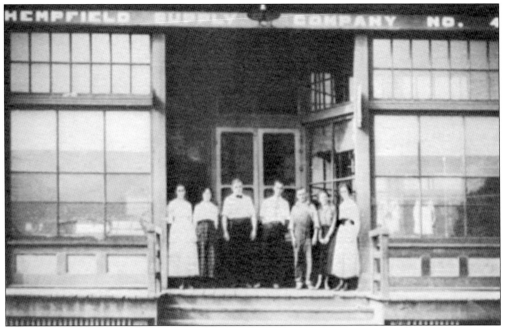

The company store at Salemville, known at the time as the Hempfield Supply Company No. 4, is seen in this photograph. Shown here are, from left to right, Sarah Barnhart Simpson, Fannie Conner, Robert Hanna, Ira Fennell, Dory Clawson, Mary Sigafoes, and Eva Barnhart. (Courtesy of Sarah Simpson and the New Alexandria Bicentennial History Committee.)

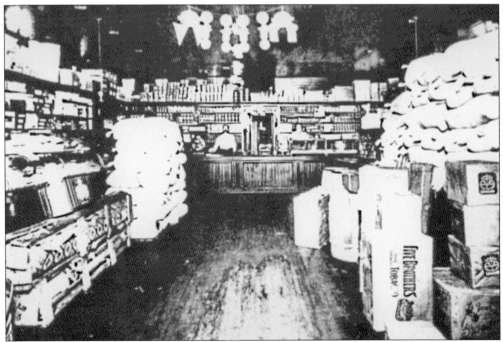

Shown here is the inside of the Jamison Supply Company Store in Crabtree. This was a full-service store, carrying just about everything a miner and his family would need. (Courtesy of Harry T. Bortz.)

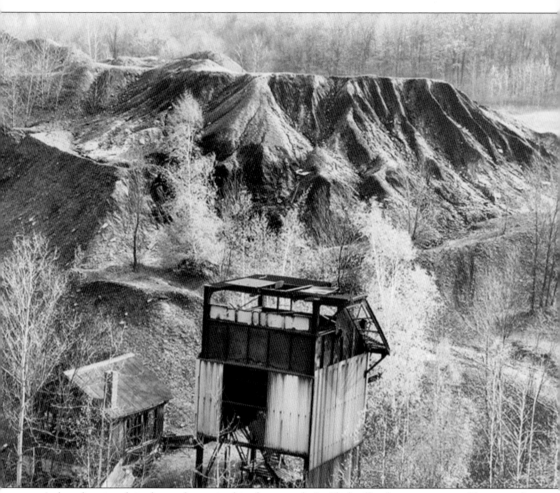

A slate dump and tipple are shown in this photograph. In Slickville, there were several large tipples from which the coal was loaded onto the railroad cars. (Courtesy of Ray Washlaski.)

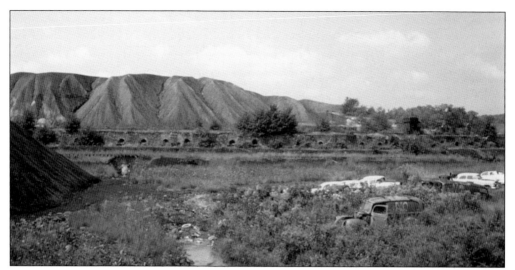

A slate dump is a collection of slate and other noncombustible materials picked out of the coal and then dumped away from the mine. Coal was available for the miners to buy, but oftentimes, to save money, the families would shift through the slate to find coal. (Courtesy of Fred Yenerall.)

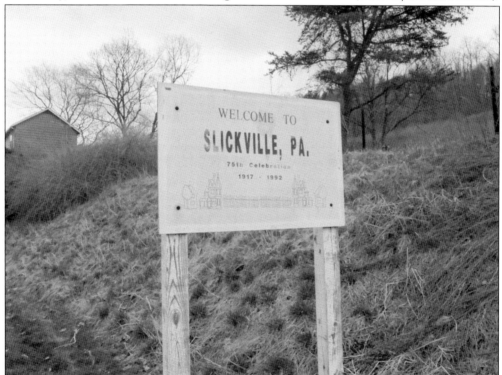

"Welcome to Slickville, PA." Slickville is an Appalachian mining community developed by the Cambria Coal Company in 1917. It was the last coal patch community founded in Westmoreland County. Slickville, with a relatively large "downtown" area shared with the adjacent town of Jamison (Elrico) and nearby Patton that contained amenities not found in older company mining towns. In its peak years, the Slickville mine employed approximately 900 men. Bethlehem Steel (formerly Cambria Steel) closed down the Slickville operations in 1943. (Courtesy of Tracy Searight.)

This is a view of First Street in Slickville on Route 819. Model patch homes lie along one side of the street. Bethlehem Steel took over Slickville in 1923 and eventually closed the operations in 1943. (Courtesy of Library of Congress.)

In 1942, five Slickville mines were closed. The town still retains most of its original company housing, along with the company store, mine car repair shop, and mine office with a jail in the basement. This is a recent view of Slickville's First Avenue and its coal patch homes. (Courtesy of Tracy Searight.)

The owner and bosses received the larger and better built homes, while immigrants and unskilled workers resided in the cheaper housing units. A common house plan called from a semidetached, two-story, wood-frame double house. (Courtesy of Tracy Searight.)

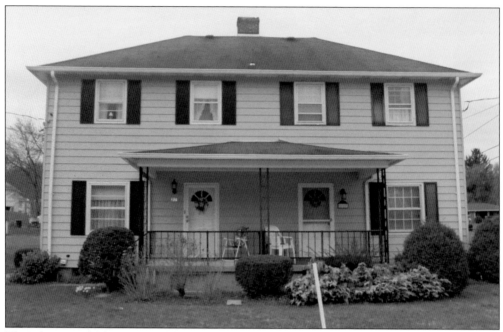

This photograph shows a current two-family patch home in Slickville. Most of the original company housing remains in good condition, but over the years several of the smaller "cottage" houses and buildings have been removed. The two-family patch homes in Slickville are either private residences or have been removed. (Courtesy of Tracy Searight.)

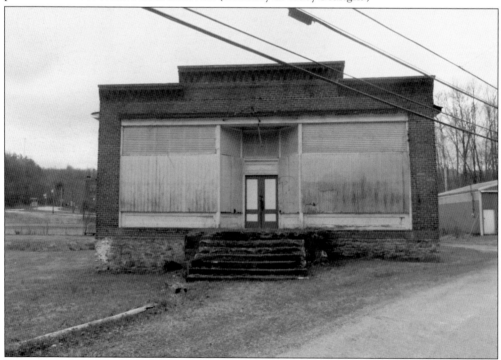

The commissary was a busy place at one time, but now stands abandoned and boarded up in Slickville. (Courtesy of Tracy Searight.)

The village of Slickville was located on the Turtle Creek Branch of the Pennsylvania Railroad and included amenities that were typically not found in older company mining towns. Its large downtown area was shared with Jamison (Elrico) and nearby Patton. Since the closing of five Slickville mines in 1942, very few historic buildings remain, and those that do are either privately owned or abandoned. This structure, dated 1918 and once a part of the coal community, is now privately owned. (Courtesy of Tracy Searight.)

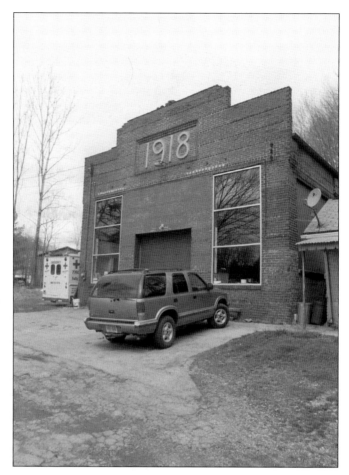

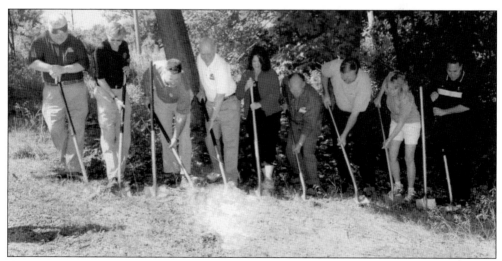

On June 14, 2007, a ground-breaking ceremony was held for phase one of the Westmoreland Heritage Trail. The five-mile trail runs between Slickville and Saltsburg. The next portion of the trail to be constructed will extend from Slickville to Delmont. (Courtesy of Ray Meehan.)

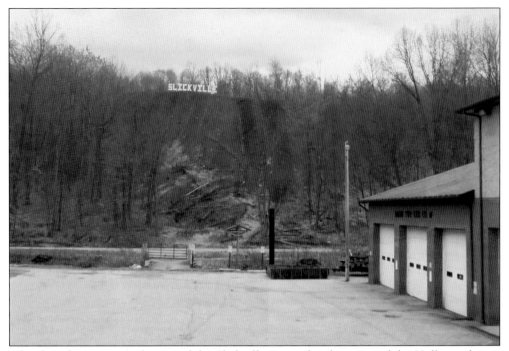

The slate dump is now the site of the Slickville sign, a local version of the Hollywood sign. The entrance of the Westmoreland Heritage Trail is at the base of the slate dump. (Courtesy of Tracy Searight.)

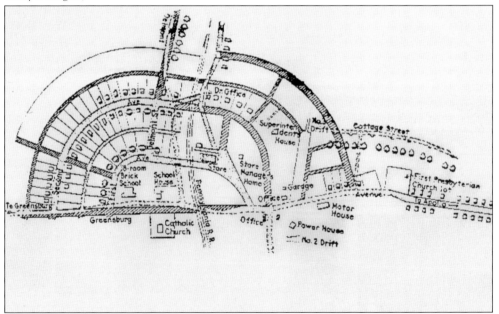

In 1942, the village of Slickville experienced the closing of five mines. During the 1950s, the Pennsylvania Railroad made a last run through the town. The railbeds from Slickville to Saltsburg were made into a hiking trail in 2007. The goal of the Westmoreland Heritage Trail is to extend the trail through Export to Trafford, eventually linking with the Great Allegheny Passage Trail system. This trail is located on property behind St. Sylvester Parish. (Courtesy of Tracy Searight.)

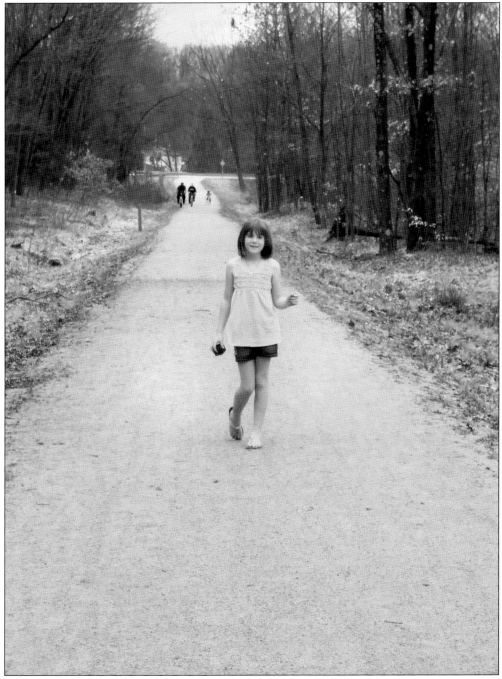

The trail as constructed is ideal for walking, jogging, bicycling, and cross-country skiing, and future trails will feature the same conditions. The trail has a wide, flat, handicapped-accessible surface and can accommodate everyone, regardless of age or physical ability. (Courtesy of Tracy Searight.)

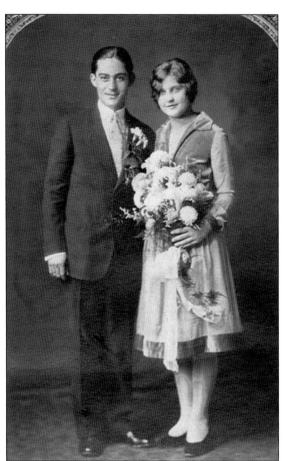

During the Great Depression, the area fell on hard times resulting in the closing of the Jamison Coal & Coke Company. The Jamison family placed the company-owned buildings up for sale. At that time a company house in Crabtree could be bought for $200. Natale and Mary Carbone purchased the community building owned by Jamison coal in 1936. The Carbones originally wanted to use the building as a pool hall, but Mary began making delicious sandwiches. Pictured are Nat and Mary on their wedding day, November 1927. (Courtesy of Carbone's Restaurant.)

The upstairs portion of the Carbone building held various activities that benefited the community, such as roller-skating and dances. The Carbones used the downstairs part of the building as a barbershop and bowling alley. Soon after opening, at the request of the pool players Mary started providing sandwiches. Carbone's restaurant has now served hungry patrons for over seven decades. (Courtesy of Carbone's Restaurant.)

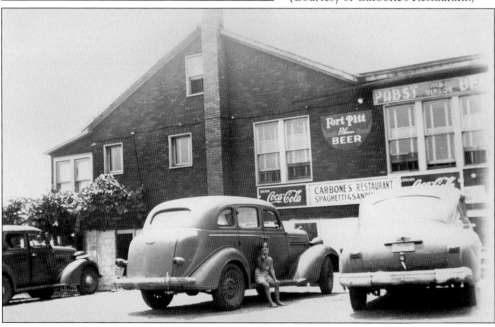

Two

CHURCHES

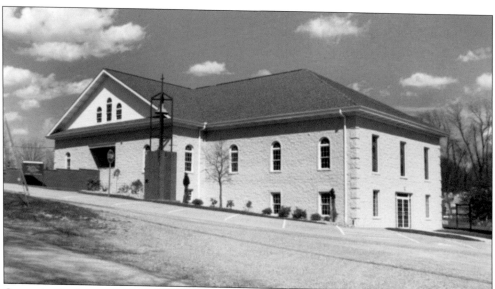

Congruity Presbyterian Church is perhaps the oldest church in Salem Township. It was established in the winter of 1788–1789. Congruity became the mother of two daughter churches, New Alexandria Presbyterian and New Salem Presbyterian. Prior to the establishment of these churches, many residents in Salem Township attended Congruity. It is located off of Route 22, five miles east of Delmont. (Courtesy of Tracy Searight.)

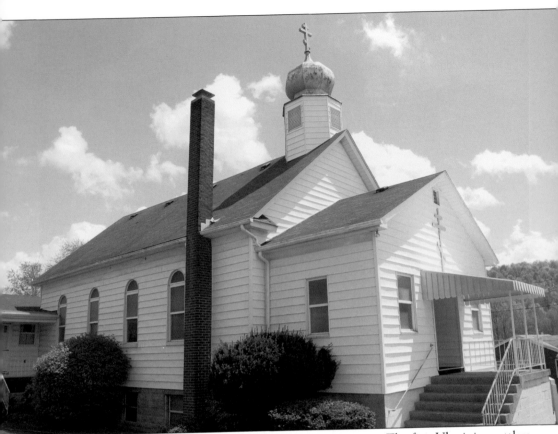

The patch community brought a variety of immigrants into area. The first Ukrainian settlers came to Slickville in the 1900s. In 1924, the Holy Ghost Church was founded and continues to serve Slickville. The Holy Ghost is a multiethnic, English-speaking Orthodox parish located in a rural area in Salem Township. (Courtesy of Rev. Father Robert Popichak.)

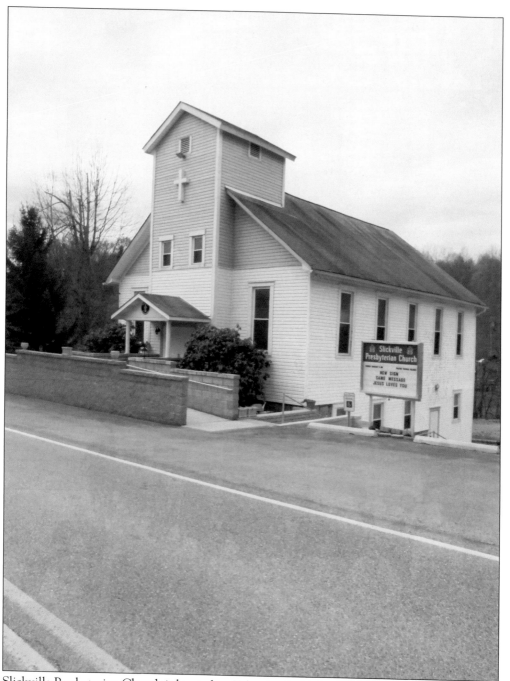

Slickville Presbyterian Church is located on Tyler Ave in Slickville. It was joined for a time with Congruity. The church was organized on June 11, 1922, by a committee composed of Dr. A.H. Jolly, the Reverend John W. Witherspoon, the Reverend O.S. Fowlers, and elders R.F. Steele and J.J.S. Rugh. A church building was erected in 1923–1924 and dedicated on November 23. (Courtesy of Tracy Searight.)

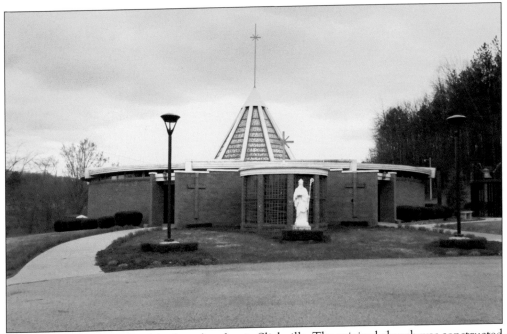

St. Sylvester Parish is one of the four churches in Slickville. The original church was constructed in the 1920s and the building dedicated on June 21, 1921. The current church was dedicated on August 11, 1963. (Courtesy of Tracy Searight.)

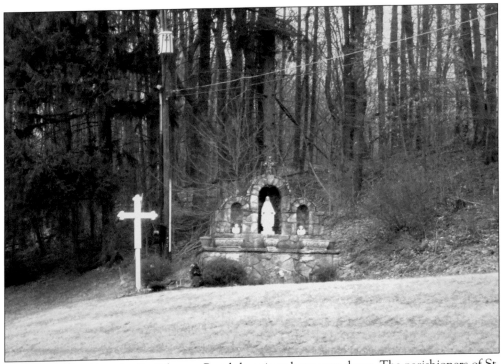

The original building for St. Sylvester Parish has since been torn down. The parishioners of St. Sylvester continue to maintain the shrine, seen here. (Courtesy of Tracy Searight.)

St. Mary's Carpatho-Rusyn Orthodox Catholic Church in Shieldsburg was built in 1906 by the Carpatho-Rusyn coal miners from the coal patches of Crabtree, Huron, Andrico, and Salemville. It is located on old US Route 22 between the Salemville patch and New Alexandria. (Courtesy of Peter E. Starry Jr.)

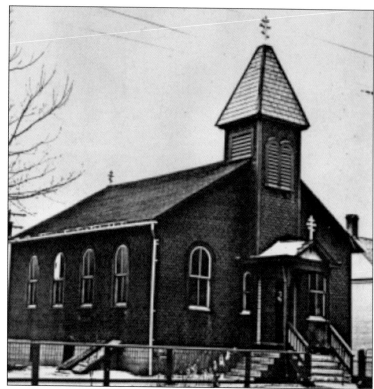

St. Mary's Ukrainian Catholic Church is shown here in 1976. Carpatho-Rusyn immigrants came to northern Westmoreland County to settle in the small mining patches of Donahue, Dundale Station (Huron), Forbes Road, Frogtown, Groff (Crabtree), Greenwald (Deweysiville), Hannastown, Highland, Luxor, and Allsworth Station (Salemville). (Courtesy of the New Alexandria Bicentennial History Committee.)

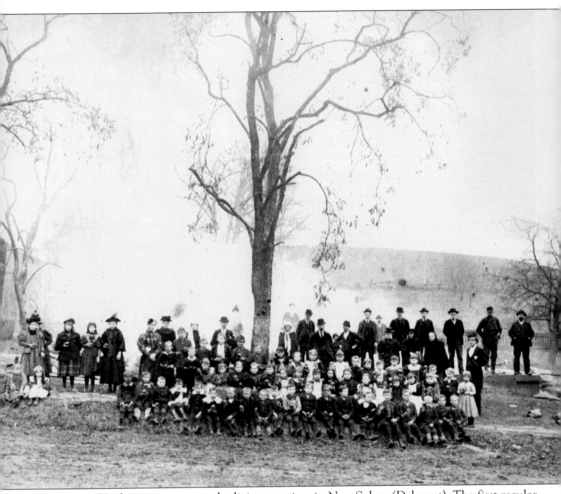

Prior to 1833, there were no stated religious services in New Salem (Delmont). The first regular service was established by Methodists in 1833. In 1892, the 24-year-old Methodist church burned down. It was located on Greensburg Street, across from the Delmont Public School. The morning after the fire, the Delmont Public School had already planned and was scheduled for its annual school photograph day. Here, the staff, students, and bystanders pose in front of the ruins of the Methodist church. Ed Wolfe took the photograph. (Courtesy of Bob Cupp.)

In 1850, the number of faithful residents had risen sufficiently that Lutheran families joined with the Reformed church members in Delmont to build a house of worship. Salem Lutheran Church (Salem Evangelical Lutheran Church) was intended for both congregations. The arrangement was known as a union church. Members of the two parishes were asked to solicit subscriptions to cover the cost of the project. The church is shown here in 1908. (Courtesy of Salem Evangelical Lutheran Church.)

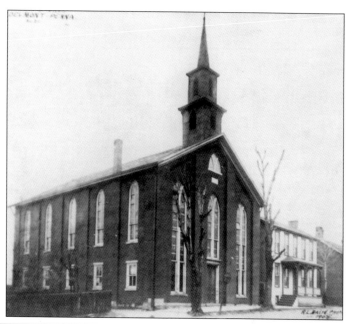

Construction on Salem Lutheran Church (Salem Evangelical Lutheran Church) began in the spring of 1850, and the 40-by-60-foot brick building was dedicated on September 11, 1850. The cost of the construction was $1,250. A little over two weeks later, on September 27, the church was finally organized. There were 36 members at the time, and it is notable that, of the 12 names on the church charter, all were male. One of the members was Jacob Earnest. (Courtesy of Salem Evangelical Lutheran Church.)

Over the years, Salem Evangelical Lutheran Church, on East Pittsburgh Street in Delmont, has been remodeled and renovated to meet the needs of the parish. A parish house and an education building have been added. Shown here is the ground-breaking ceremony in 1963 for the two-story education building. (Courtesy of Salem Evangelical Lutheran Church.)

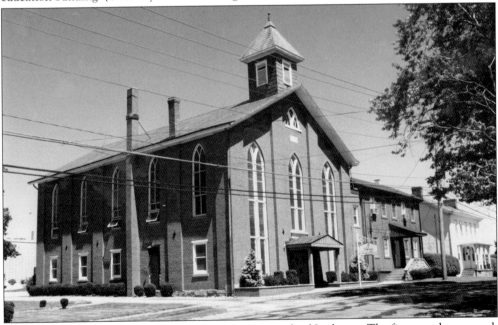

The steeple shown here was not original to Salem Evangelical Lutheran. The first steeple was stuck by lighting, so this model was placed on the church. Eventually, one that more closely reflected the original version was built. (Courtesy of Salem Evangelical Lutheran Church.)

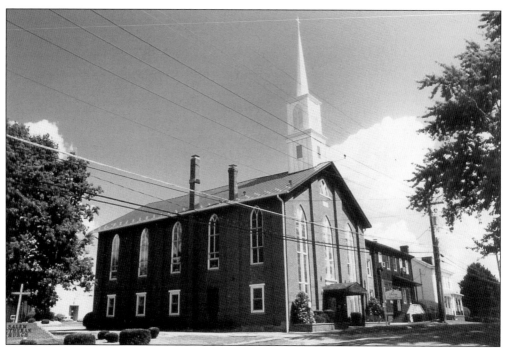

Salem Evangelical Lutheran Church is located on East Pittsburgh Street, at the top of the hill. This is how it looks today. This spire was placed on the church in 1994. (Courtesy of Salem Evangelical Lutheran Church.)

The New Salem Presbyterian Church (now Delmont Presbyterian Church) was organized from the Congruity congregation on December 25, 1849. It was distinguished from Salem Church, known as Old Salem, founded in 1786 in Derry Township. (Courtesy of Bob Cupp.)

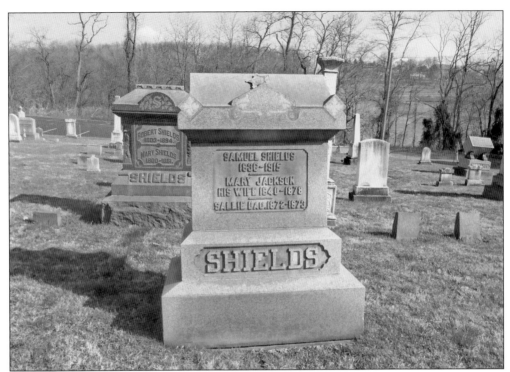

The Delmont Presbyterian Church cemetery includes some of Delmont's most famous citizens. Robert Shields and his son Samuel are buried here. (Courtesy of Tracy Searight.)

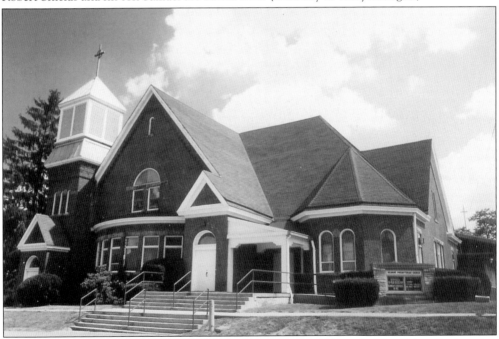

Delmont Presbyterian Church was organized on Christmas Day 1849 as the New Salem Presbyterian Church. At the time, there were only 72 charter members. Many of the founding citizens are buried in the cemetery. (Courtesy of Tracy Searight.)

Trinity United is one of the original churches located on East Pittsburgh Street. The church is a part of the Christmas in Salem Crossroads Pilgrimage that Delmont hosts the first weekends in December. (Courtesy of Tracy Searight.)

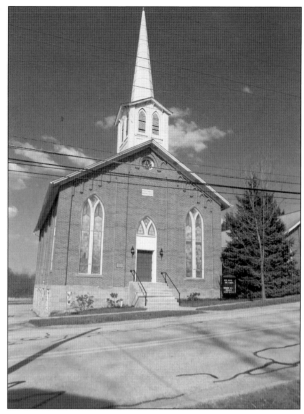

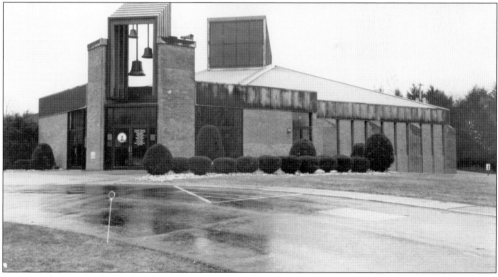

Many Delmont Catholic families were attending church at St. Sylvester's in Slickville or St. Mary's in Export. The idea of establishing a Catholic church in Delmont was born in February 1941, and the site was chosen later that year. The first mass was held on March 9, 1949, in a renovated one-story chicken coop across from the old Villa D'Esta on old Route 66. H.C. Kramer, owner of Twin Valley Cemetery, donated land for a new Catholic church, and in September 1950, ground was broken on St. John Baptist de la Salle. (Courtesy of Raymond Meehan.)

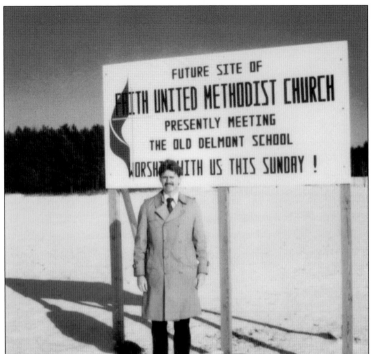

Faith United Methodist Church began in the bottom portion of the Delmont School in 1989. Rev Deryl Larsen stands at the future site of the church building. (Courtesy of Faith United Methodist Church.)

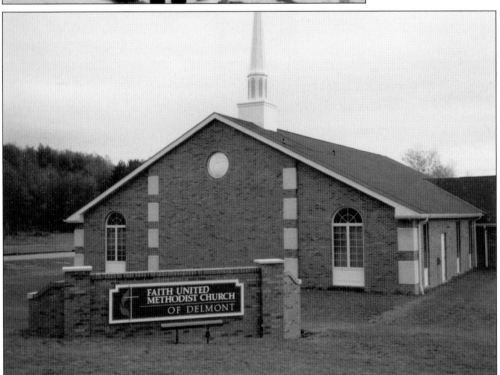

This 1990 photograph shows Faith United, newly built. This church is included on the itinerary of the yearly Christmas in Salem Crossroads Pilgrimage. (Courtesy of Faith United Methodist Church.)

Three

SALEM CROSSROADS' WATER TROUGH

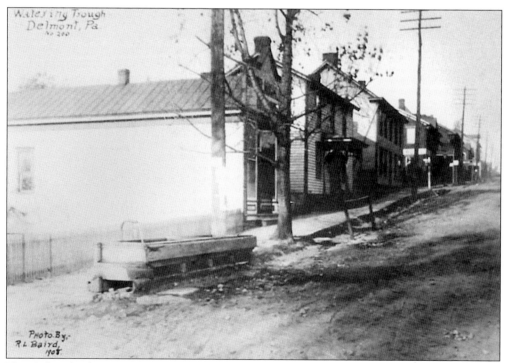

New Salem (Delmont) was built around a large spring. Hugh Bigham laid the first wooden water line to the water trough located in the center of town in 1810. The original wooden trough was replaced several times, including by the version shown in this 1908 photograph looking west on Pittsburgh Street. This trough was torn down and replaced with a concrete version in 1910. (Courtesy of Robert Z. Yaley.)

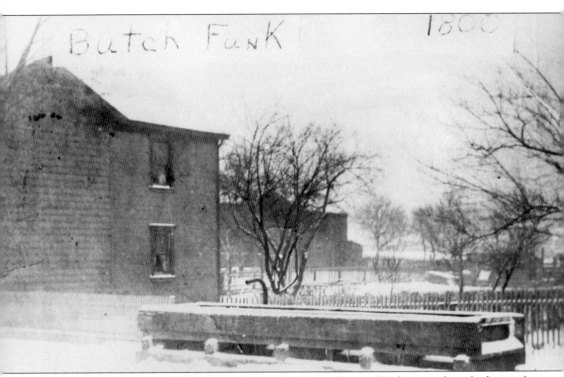

The trough was a dependable source of water for the residents of Delmont, who relied on it for all of their water for drinking, bathing, cooking, and washing clothes. Even after running water was made available in homes, residents continued to use and drink from the trough. As late as the 1960s, people would line up on a Sunday afternoon to take turns washing their cars. It was not until the 1970s that the water did not meet the standards of the Pennsylvania Department of Environmental Resources and the trough's supply from the "Big Spring" was discontinued. (Courtesy of Leslie Tsouris.)

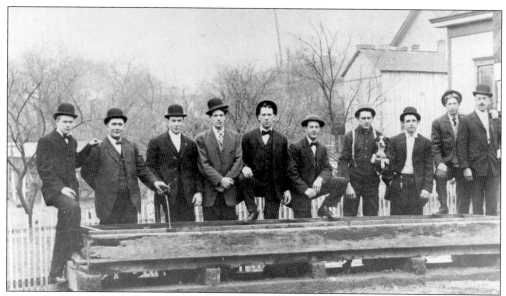

The water trough was a busy place. The running water flowed from the Big Spring, located 100 feet away, and the trough had been replaced several times due to rotting. In the far left of this 1910 photograph, the trough clearly shows signs of weathering. Later that year, the wooden trough would be replaced with a concrete version. The men in the photograph are, from left to right, Ralph Rickinson, Elmer Walp, two unidentified men, Bob Queery, Ed Lutz, two unidentified men, Harry Lutz, and Seymore Metz. (Courtesy of Charles A. Hall.)

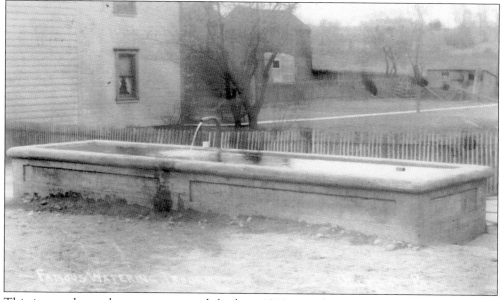

This image shows the concrete trough built in 1910 to replace the wooden troughs, which would rot over time. The concrete version is larger than the earlier troughs. (Courtesy of Robert A. Yaley.)

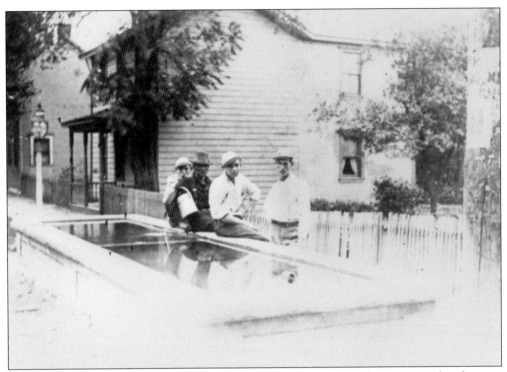

This photograph, taken on August 12, 1914, shows men on a warm day enjoying the pleasures of a refreshing, cold drink from the Big Spring's water. The gentlemen in the photograph are, from left to right, Charles Funk, Bill Alexandra, Frank Turney, and Harry Funk. (Courtesy of Leslie Tsouris.)

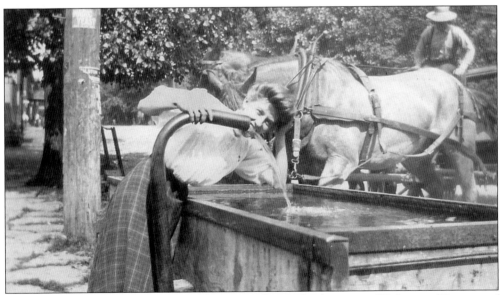

The water trough provided a dependable source of water for the town of Delmont. (Courtesy of Lysle Bash.)

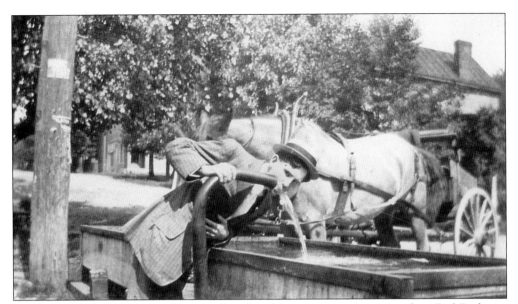

In 1910, after the water trough was replaced with a concrete version, resident Earl Bathgate commented, as he took a sip from the pipe, that the water was "good for man or beast." (Courtesy of Lysle Bash.)

As the years went on, the water trough decreased in size. In this 1954 photograph, the pipe continues to pour out water from the Big Spring, which never ran dry. The larger concrete trough built in 1910 lasted until the 1930s, when it was hit by a truck. The trough would continue until the 1970s, at which time the Department of Resources shut it down due to poor water quality. (Courtesy of Leslie Tsouris.)

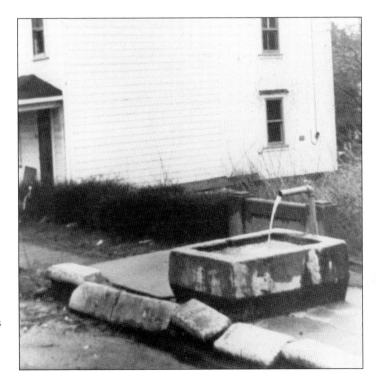

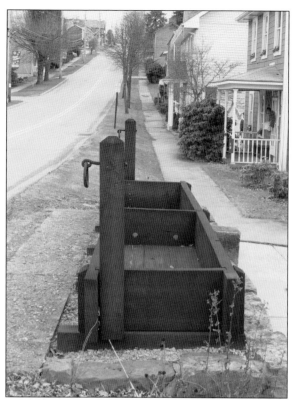

The water trough is now located on East Pittsburgh Street, which was originally known as Main Street. Although the original trough's exact location is not known, it has been at or near this spot for almost two centuries. (Courtesy of Bob Cupp.)

The water trough is a significant landmark in Delmont. In an effort to preserve the town's history, the Delmont Lions Club in 1973 restored the watering trough to its wooden construction. The base of the trough was used with cut stones from the foundation of Shields Farm, which is located just down the street. On the stone in the center of the photograph is engraved the year 1810. (Courtesy Tracy Searight.)

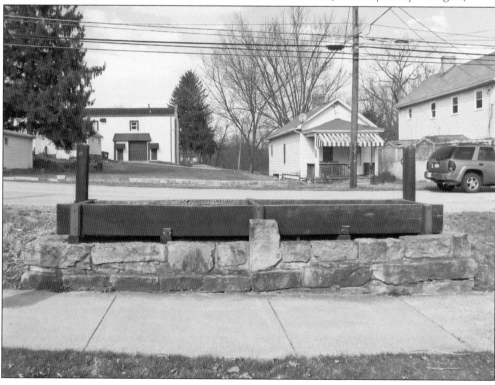

Four

DELMONT–NEW SALEM BOROUGH

In 1784, William Wilson received a warrant issued to him on November 8 of that year. The original tract of land was 300 acres and located in part of Salem Township. Wilson traveled from Salem, Massachusetts, and it is written that this is where he derived the name New Salem for the property. Wilson built a log cabin and remained on his 300-acre farm until his death in 1796. The estate was divided among his two sons—Thomas and George—six sisters, and husbands of two of them, who conveyed all the deeds over to Thomas. In 1812, the patent was validated and Thomas Wilson laid out the property into 48 lots, forming a crossroads village. (Courtesy of Archives and History Pennsylvania State Archives.)

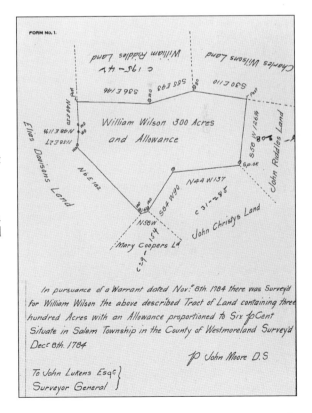

51

The Pennsylvania State Legislature incorporated the village of New Salem into a borough in 1833. Any ordinance enacted by the burgess and council was embossed with a borough seal. This illustration shows the seal, which was first used on May 28, 1835, to certify notice from the state senate clerk when it was copied into the New Salem Borough minute book. It also appeared in Ordinance 1, enacted two mothers later, on July 31, 1835, which taxes theatrical or other public exhibitions. For two months, the town had a seal with a backwards *s*. (Courtesy of Murrysville Library.)

Located on the outskirts of Delmont is one of the oldest burial grounds in the county. This cemetery, known as Lessig Cemetery (also called Riddle Cemetery), is situated in the wooded area near the Apple Hill Playhouse. The graves of county judge John W. Riddle and his wife are located here. (Courtesy of Tracy Searight.)

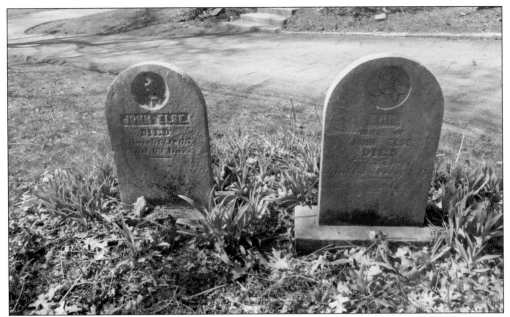

There are several bodies buried in Lessig Cemetery, many of which are marked only by stones, not engraved tombstones. Shown in this photograph are two of the graves that are marked by engraved tombstones, those of John Elise (died 1865) and Ann Elise (died 1871). (Courtesy of Tracy Searight.)

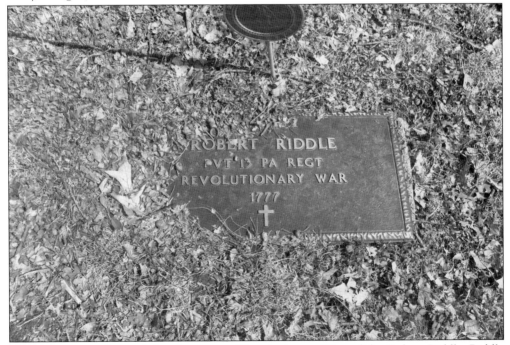

Lessig Cemetery also includes the grave of Revolutionary War solider Robert Riddle. Riddle was buried in the cemetery in 1777, but a 1934 document revealed that his grave was still without a tombstone. Several years ago, Riddle was finally given a proper marker. (Courtesy of Tracy Searight.)

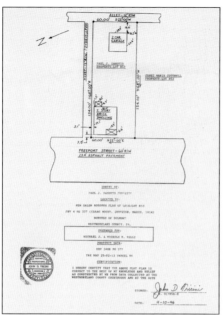

On March 3, 1814, Thomas Wilson laid out the original town into 48 lots, numbered 1 through 48. The lots were surveyed and plans were made by Isaac Moore. Wilson sold these lots at a public auction on December 23, 1814. Prices ranged from $12 to $25. Lot number 25 was purchased by Joseph Reed for $15. This is a copy of the survey of one of the original lots, located at 33 Freeport Street. (Courtesy of Michelle Kelly.)

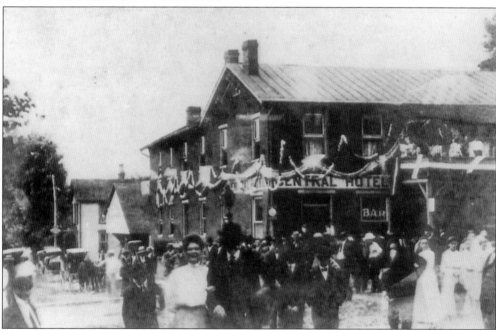

The Central Hotel was a busy saloon along the Northern Turnpike. In 1882, it was known as Snyder's; the name was later changed back to Central Hotel. The first owner was Robert Black. Behind the Central Hotel was a barn used by stagecoach drivers for changing horses. Stagecoaches traveled about 10 miles an hour, and fresh spans of horses awaited the coaches every 10 or 12 miles. Passengers traveled all day and night, and if they stopped for a night of rest at a tavern, they were likely to find the stage filled the next morning. The regular travel time between Pittsburgh and Philadelphia was about 56 hours, with two coaches leaving and arriving daily in Pittsburgh. The barn and garage in the rear of the property burned down in January 1921. Men installing electric power in the town helped extinguish the blaze. (Courtesy of Bob Cupp.)

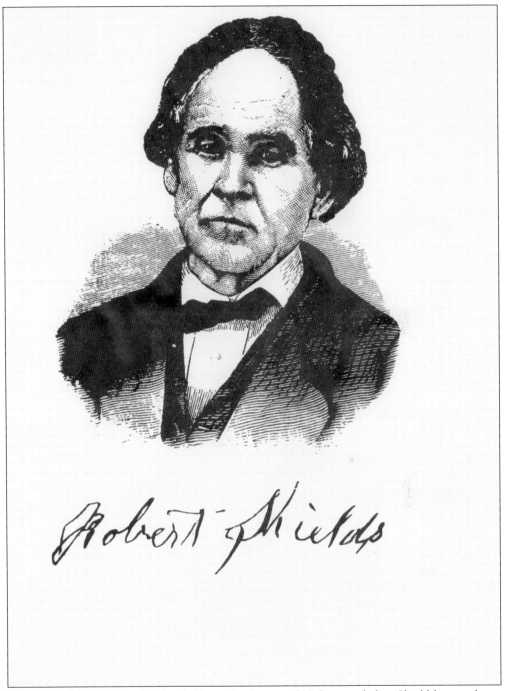

Robert Shields was one of eight children. At the age of 19, he traveled to Shieldsburg to learn the tanning business. Shields ran several businesses and owned a vast amount of land. He was appointed one of the town's original councilmen and later served as New Salem burgess. Robert and his wife had 11 children, including Samuel. (Courtesy of Alice Cathey.)

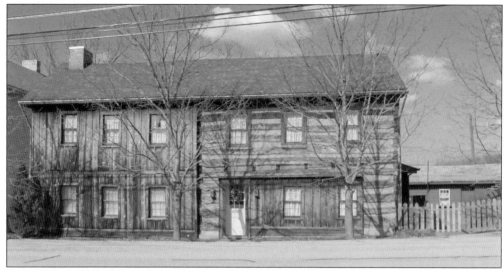

By 1825, Robert Shields was running a tannery in Salem Crossroads, where his father had bought two lots from John Hutton, one of the original lot owners. This photograph shows his home on East Pittsburgh Street. By the time New Salem Borough was incorporated in 1833, the town was a popular stopping place for stagecoaches along the Northern Turnpike. Shields made improvements and additions to the tannery, continuing to run the business until 1870. Shields also bought out the saddler and harness-making business of John B. Plumer and owned a boot and shoe factory. (Courtesy of Tracy Searight.)

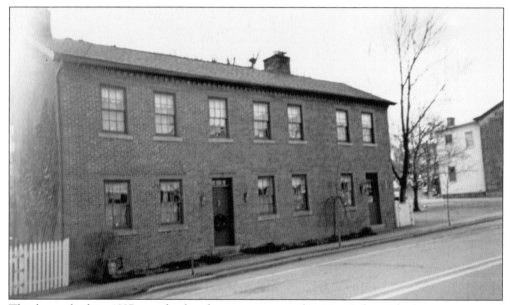

This home, built in 1827, was the fourth structure erected in New Salem. The house was owned by Jacob Earnest, an excellent gunsmith and wood-carver. Earnest owned several lots in New Salem, including the one next to his house, where he operated his gunsmith shop. The shop is no longer there, but the Earnest family donated the land to the town. The lot is now a park, and includes the traffic dummy that was on old US Route 22 (now Greensburg Street), a wishing well, benches, and trees. (Courtesy of Tracy Searight.)

This photograph shows Jacob Earnest, gunsmith and wood-carver. It is documented that he was the descendant of Indian Eve. Earnest moved to Salem Crossroads in 1830. In 1833, he was taxed for a house and a lot valued at $200 and a "gunsmith" valued at $100. Earnest served several terms as borough councilman. On September 27, 1850, his name was received as desiring to unite with the congregation of Salem Lutheran Church. Earnest died on March 6, 1884, and is buried, along with his wife, in Eastview Union Cemetery, next to the Salem Evangelical Lutheran Church on East Pittsburgh Street in Delmont. His rifles are among the finest in Westmoreland County. (Courtesy of Leslie Tsouris.)

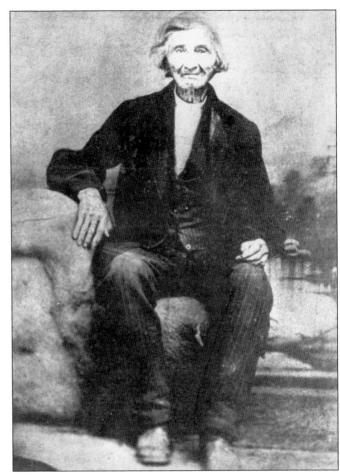

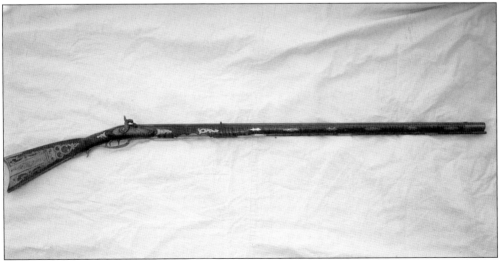

This photograph shows an original Jacob Earnest rifle. Earnest's handcrafted rifles are among the finest in Westmoreland County. An excellent wood-carver, Earnest would engrave his name onto the rifles. (Courtesy of Matt Stein.)

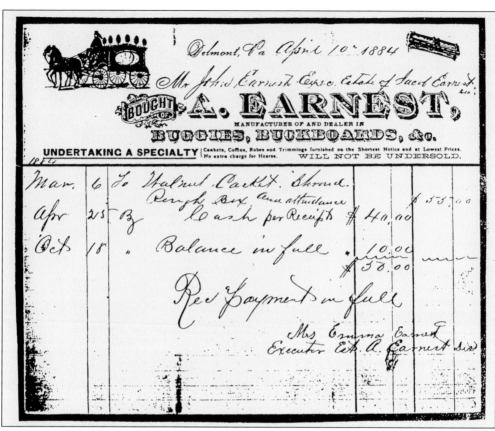

This is the receipt for Jacob Earnest's casket. His son, A. Earnest, was the town's undertaker. Listed for March 6 is a walnut casket. (Courtesy of Leslie Tsouris.)

Delmont was always one for local gossip and news. A local newspaper called the *Evening Press* included a section called Delmont Doings. Pictured here is a page from an 1884 edition, including a mention of Earnest's death: "Mr. Jacob Earnest, one of our oldest citizens, died Thursday evening. Mr. Earnest was in his usual good health until within a day or two." Jacob Earnest's son Albert was New Salem's undertaker and provided the casket for his father's burial. (Courtesy of Leslie Tsouris.)

This is an account list from the estate of Jacob Earnest. This itemization shows debt owed by the Earnest estate, which includes, among many items, a casket shroud, coal, and school taxes for 1884. (Courtesy of Leslie Tsouris.)

This document, signed by the orphan's court on May 31, 1884, includes the total assets, credits, and balance due from Jacob Earnest's estate on behalf of his son John Earnest. Even weeks after Jacob died on Mary 6, 1884, his son John was still taking care of matters related to his estate. (Courtesy of Leslie Tsouris.)

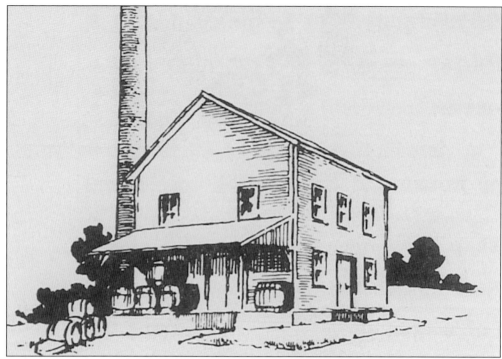

Hugus and Company was the largest enterprise in town in 1869. The stockholders—John Hugus, Daniel Potts, Michael Hugh, and Cyrus Walton—built a distillery, also referred to as a stillhouse, with a production capacity of 150 bushels per day. On August 4, 1873, a fire of mysterious origin destroyed the building and machinery. (Courtesy of Jean Troxell Kaufman.)

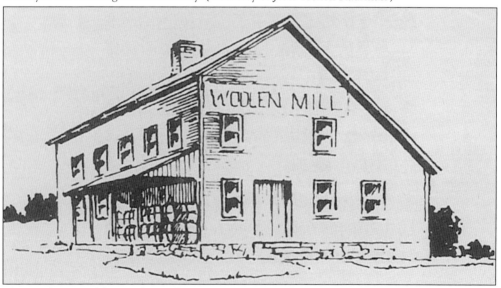

This is a drawing of the Woolen Mill in New Salem Borough (Delmont). Henry Hugus Sr. started the manufacturing plant for carding wool in 1830. When wool is carded, the fibers are straightened to make spinning the wool into yarn easier. The mill was located in the triangle of land at Greensburg Street and Route 66, where the Delmont Public School was built. In the 19th century, wool was a major industry in New Salem Borough. (Courtesy of Jean Troxell Kaufman.)

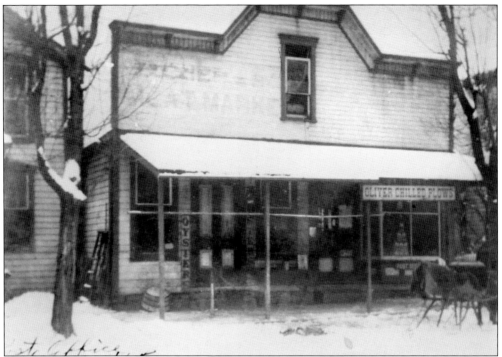

New Salem (Delmont) has had several post offices over the years. This one was in a store that likely was on what is now Greensburg Street, next to J. Doncaster's Photography. (Courtesy of Bob Cupp.)

The postcard is in the possession of Melissa Herman, owner of Salem Antiques. Shown here is the back of the card. New Salem's post office was established as Salem X Roads (Salem Crossroads) on November 7, 1812. The name of the post office on the postcard is Salem X Roads (Salem Crossroads), which indicates that it was made before Zachariah Zimmerman became postmaster in 1871 and changed the name of the post office to Delmont, and prior to him moving the post office into his drugstore. This dates the postcard to sometime between 1860 and 1871. (Courtesy of Melissa Herman.)

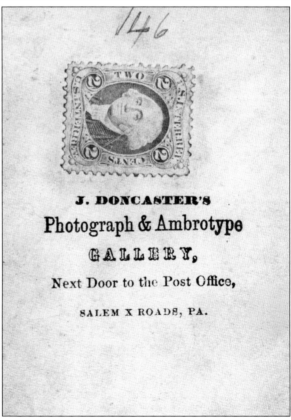

J. DONCASTER'S
Photograph & Ambrotype
GALLERY,
Next Door to the Post Office,
SALEM X ROADS, PA.

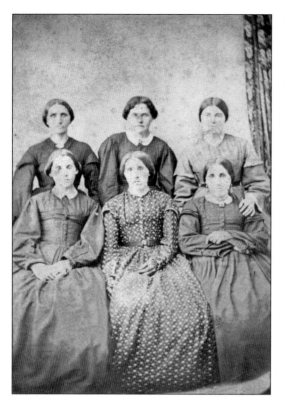

The front of the postcard by J. Doncaster Photography is of six New Salem women. They are unidentified but give an indication of the style and bearing of the women who lived in New Salem Borough (Salem X Roads) during this period. (Courtesy of Melissa Herman.)

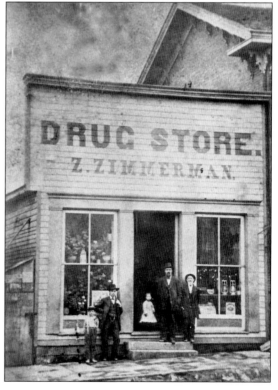

Zachariah Zimmerman was born on June 26, 1828. He went on to attend Duff's Mercantile College in Pittsburgh. In 1860, he began a drug business, the first of its kind in New Salem Borough, located on West Pittsburgh Street. In 1888, from left to right, are Charles Borland, W.J. Zimmerman, Mary Z. Lauffer (W.J.'s daughter), John Alexander, and Zachariah. (Courtesy Lysle Bash.)

The Central Hotel was the center of a lot of activity over the years. Delmont residents have always loved celebrating a parade. Here, residents and visitors wait patiently on Greensburg Street to watch a holiday parade. (Courtesy of Delmont Borough.)

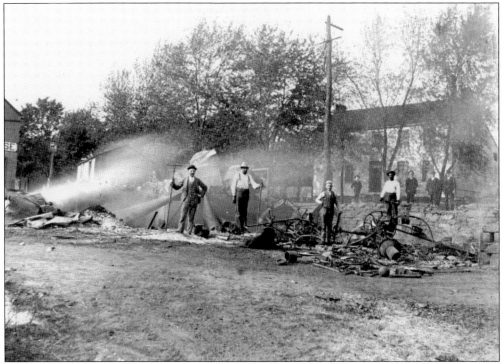

On April 1, 1881, Daniel Shuster purchased a flour mill from John Hugus. In this photograph, men stand among all that remains of the mill after the fire of 1892. (Courtesy of Joseph W. Shuster.)

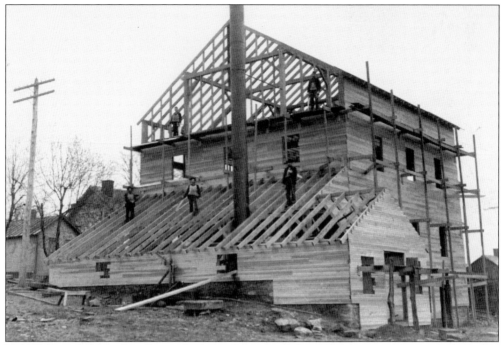

In 1893, Daniel Shuster's mill was rebuilt on a larger scale. It was known around town as the "roller mill" because of the steel rollers that were used to crush the grain. In census records, Shuster lists his occupation as "farmer." (Courtesy of Joseph W. Shuster.)

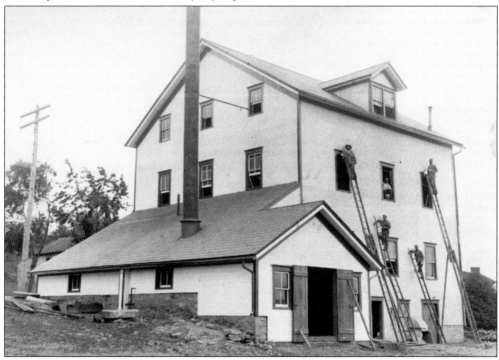

This photograph shows the rear of Shuster's mill during the final stages of construction. It was rebuilt after the previous mill burned down in 1892. (Courtesy of Joseph W. Shuster.)

The original flour mill was destroyed by fire on September 2, 1842, was rebuilt in 1843 by Jack and John Brown. In 1847 John Brown sold share of the Mill to John Hugus. A few years later, when Jack Brown died, John Hugus became the sole owner until 1881. On April 1, 1881, the mill was purchased by Daniel Shuster. (Courtesy of Joseph Shuster.)

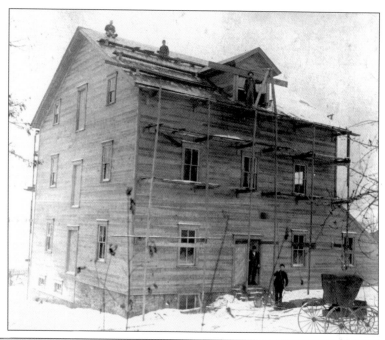

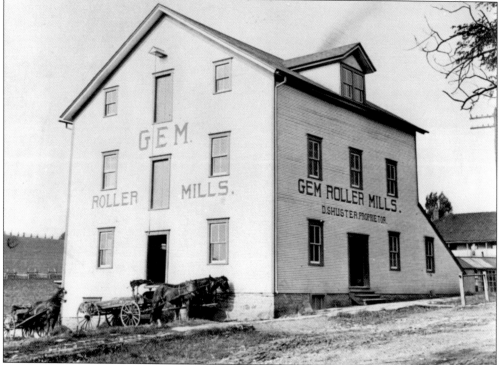

Daniel Shuster's mill opened for business shortly after being rebuilt in 1892. Shuster ran the mill for another nine years, until his death in 1901, at which time his son Cyrus Shuster, also known as C.J., became the owner. Shuster Mill remained in the Shuster family and served Delmont for 64 years. This building is now home to the Agway store on West Pittsburgh Street. (Courtesy of Joseph Shuster.)

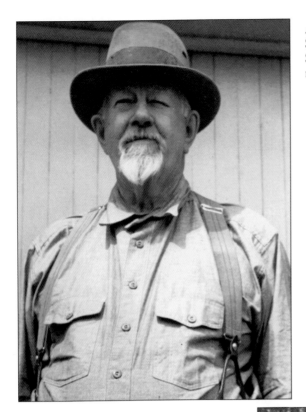

After the death of his father, Daniel Shuster in 1907, Cyrus Jacob "C.J." Shuster became the owner of the flour mill. (Courtesy of Joseph W. Shuster.)

C.J. Shuster (1856–1947) was an important resident and business man in New Salem Borough (Delmont). Besides owning the mill, he was the president of the People's National Bank during its four-year operation. He was also very active in the Salem Lutheran Church (Salem Evangelical Lutheran Church). (Courtesy of Joseph W. Shuster.)

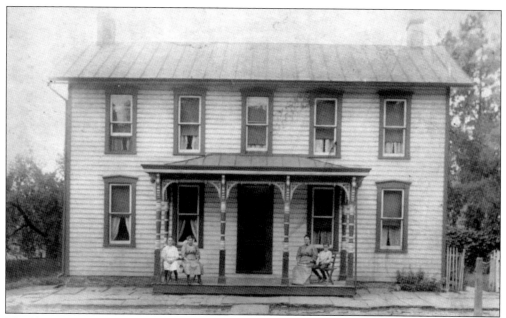

The Shusters were longtime Delmont residents who contributed to the community. This photograph shows the Shusters at home in New Salem Borough (Delmont) in the late 1920s. (Courtesy of Joseph W. Shuster.)

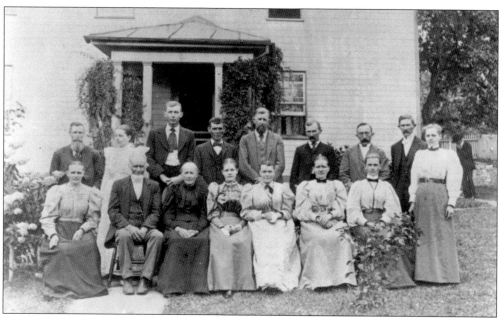

Shuster family members pose for a photograph. Shown are, from left to right, (first row) Harriet M. Shuster (Mrs. J.M. Silvis), Daniel Shuster, Lucinda Rugh Shuster, Maggie A. Shuster (Mrs. J.M. Lingensmith), Maggie E. Rowe (Mrs. C.J. Shuster), Melvina Shuster (Mrs. F.C. Black), and Clara B. Shuster (Mrs. C.R. Fritchman); (second row) Joseph M. Silvis, Minnie Shuster, Albert J. Shuster, J.M. Klingensmith, Cyrus Jacob Shuster, Frank C. Black, Charles R. Fritchman, Clark W. Earnest, and Gertrude Shuster (Mrs. C.W. Earnest). (Courtesy of Joseph W. Shuster.)

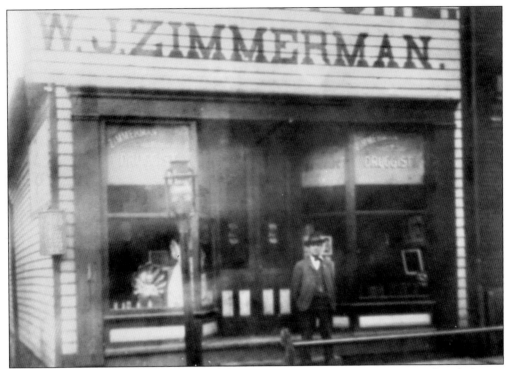

This photograph shows W. John Zimmerman in front of his store on West Pittsburgh Street. Zimmerman entered the drugstore business with his father, eventually purchasing, along with his brother in-law R.T. Hugus, the business from Zachariah. In 1907, there were seven telephones in New Salem, and in 1910, John installed the first telephone switchboard in his drugstore. John continued his business until 1927, when he sold the store and retired. Later, Joe Volek and then a man named Livengoods operated a grocery store at the site of the former store. Ralph's Tavern is now located where Zimmerman's store once stood. (Courtesy of Raymond Meehan.)

This is a street view of W.J. Zimmerman's drugstore. In addition to medicine, a variety of household supplies could be purchased at the store. (Courtesy of Raymond Meehan.)

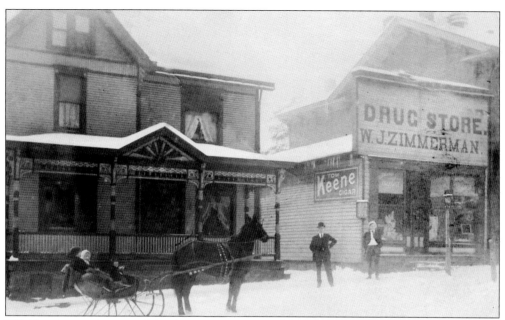

W.J. Zimmerman is pictured (in the center, wearing a black bowler hat) with his four children in the carriage in front to his New Salem drugstore and home. Zimmerman and his brother-in-law R.T Hugus purchased the drugstore from W.J.'s father, Zachariah. In 1893, Hugus sold his share to Zimmerman, who built this house next to his drugstore in 1897. (Courtesy Robert Z. Yaley.)

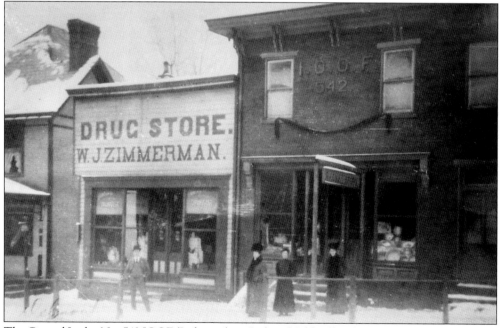

The Carmel Lodge No. 542 IOOF (Independent Order of Odd Fellows) was established in Delmont on May 22, 1858. The first noble grand of the order was John Doncaster. Zachariah Zimmerman was a member, and he eventually became noble grand. Zimmerman opened his drugstore beside the IOOF at what is now 14 West Pittsburgh Street. (Courtesy of Robert Z. Yaley.)

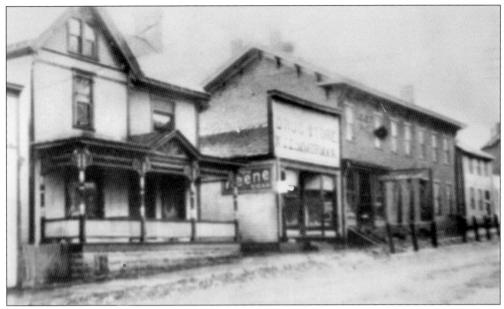

This is the front view of W.J. Zimmerman's house and drugstore. Next to the drugstore is the IOOF. On the back of this photograph is the following information: "Contractors George Sarver, Dave Kaylor. Built in 1897, W. Zimmerman moved in October 1897 sold to Paul Thomas 11/29/27 bought back at Sheriff sale 9/2/32 sold to A.S. Macheaney 11/16/32 Joe Voleck in store 11/1/32 city water 1952 moved back to house 10/16/84." (Courtesy of Raymond Meehan.)

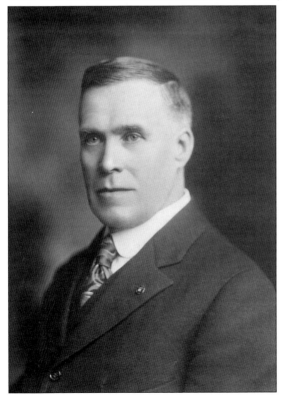

William John Zimmerman, the only son of Zachariah Zimmerman and Catherine Walters Zimmerman, was born on July 11, 1860. He married Anna M. Buchanan from Congruity. They had eight children. W.J. followed in his father's footsteps and eventually purchased the drugstore business from Zachariah. W.J. had the first local phone installed in his drugstore to provide a direct line to physicians. He lived in Delmont for a century, retired in 1927, and died at age 100. He recorded the events of Delmont in scrapbooks and notebooks that he complied for more than seven decades. (Courtesy of Robert Z. Yaley.)

Melissa Herman, owner of Salem Antiquities, found a glass medicine bottle from Delmont's own W.J Zimmerman. The bottle still has the original cork and contents. Printed on the front is "W.J. Zimmerman Druggist, Delmont, Pa." and written by hand is the word *oil*. (Courtesy of Tracy Searight.)

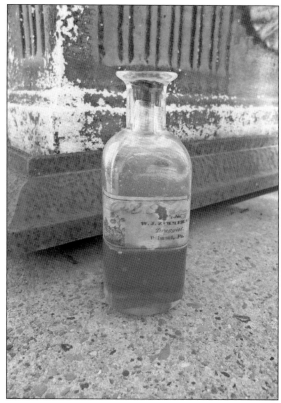

On December 9, 1898, the Delmont Public School was dedicated. Cyrus M. Christy was the first principal. The new building, shown in this photograph, was made possible by the Public School Act and contained four rooms, two halls, a principal room, two furnaces, a playroom, and a washroom in the basement. Among the newest innovations were artificial slate blackboards and single seats. The school district included what are now parts of Murrysville, Washington, and Salem Townships. The course of study included the Bible, Cobb's readers, and Goff's arithmetic. (Courtesy of Robert Z. Yaley.)

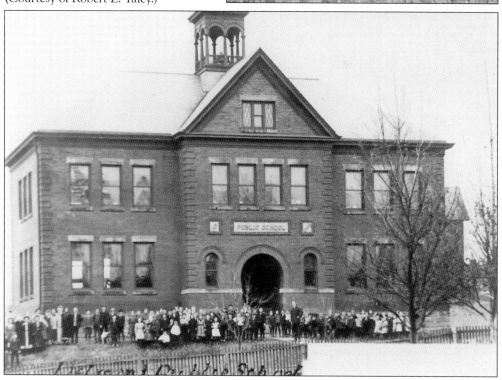

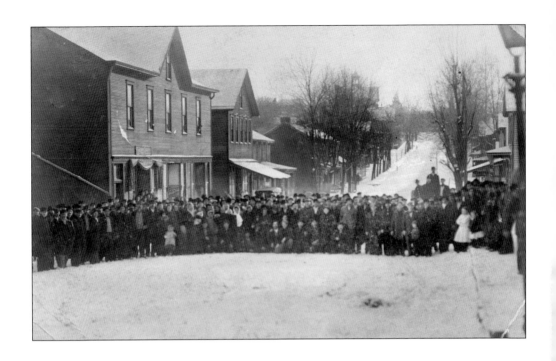

This is a view of Delmont residents gathered on Greensburg Street in 1911. The image appeared on a postcard sent to Alex Hamilton, who at the time lived in Export. The postcard was from his violin teacher, letting him know he was unable to visit for violin lessons due to a sprained ankle. (Both, courtesy of Brian Hamilton.)

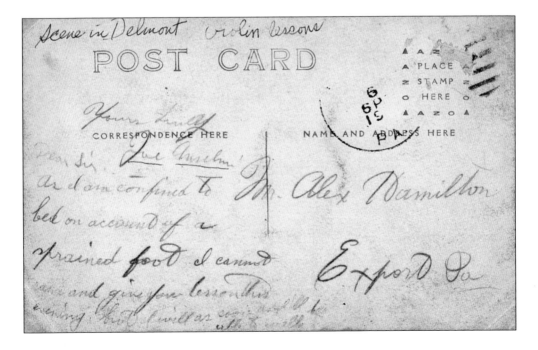

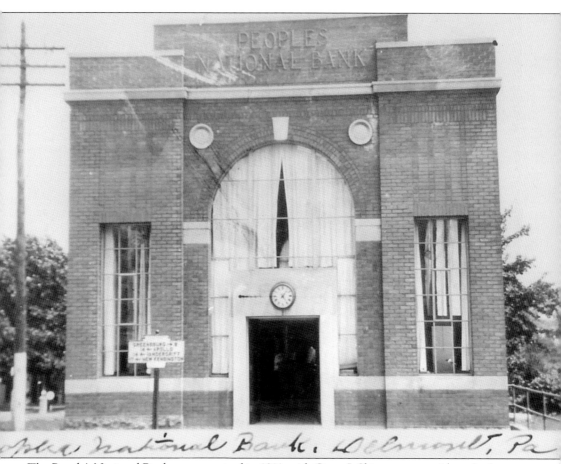

The People's National Bank was organized in 1911, with Cyrus J. Shuster was president. In August 1926, on the corner of present-day Greensburg and Pittsburgh Streets, construction began on a new bank building. In October 1930, the bank began experiencing heavier withdrawals, and on June 4, 1931, it closed its doors. In the saga of New Salem borough, it is recorded that "S. R. King the former assistant cashier was indicted by a federal grand jury in Pittsburgh for embezzling $17,000." (Courtesy of Robert Z. Yaley.)

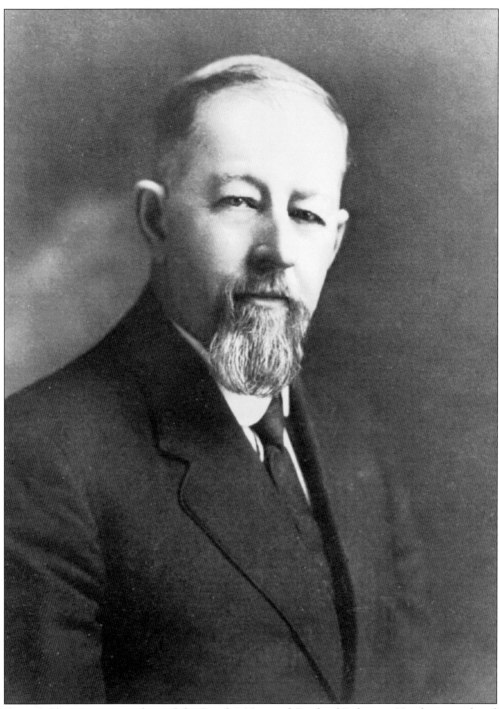

Cyrus J. Shuster was president of the People's National Bank of Delmont. He also owned and operated Shuster's Mill. (Courtesy of Joseph W. Shuster.)

Five

ROADWAYS

The tollhouse in Delmont was located on the S-curve on the Northern Pike Road. Although the original tollhouse has since been torn down, this is an example of what it would have looked like. Built in 1819, this was the last surviving tollhouse on the Old Northern Turnpike. (Courtesy of Tracy Searight.)

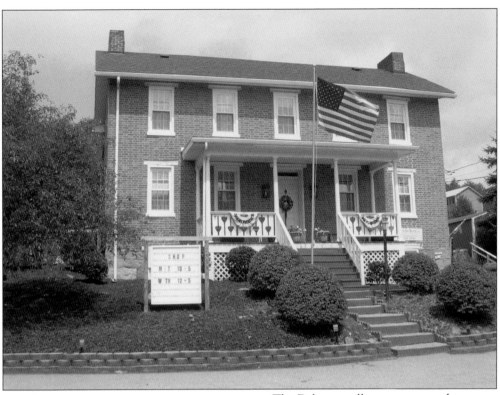

TOLL RATES

For every score of Sheep or Hogs.	6 Cents
For every score of Cattle.	12 Cents
For every Horse and Rider.	4 Cents
For every led or driven Horse, Mule, or Ass.	3 Cents
For every Sleigh, or Sled drawn by one horse or pair of Oxen.	3 Cents
For every Horse or pair of Oxen in addition.	3 Cents
For every Dearborn, Sulky, Chair, or Chaise with one horse.	6 Cents
For every Horse in addition.	5 Cents
For every Chariot, Coach, Cochee, Stage, Phaeton or Chaise with two Horses and four wheels.	12 Cents
For every Carriage of pleasure by whatever be it called, the same according to the number of wheels and horses drawing the same.	
For every Cart or wagon whose wheels do not exceed three inches in breadth, drawn by one horse or pair of oxen.	4 Cents
For every Cart or wagon whose wheels exceed three inches and does not exceed four inches in breadth or every horse or pair of oxen drawing the same.	4 Cents
Wheels exceeding four and not exceeding six inches.	5 Cents
Wheels exceeding six and not exceeding eight inches.	2 Cents
All Carts or Wagons whose wheels exceed eight inches in breadth.	Free.

The Delmont tollgate, now torn down, once operated at this location, on the north side of the S-curve on what is now West Pittsburgh Street at Tollgate Lane. The property was owned by Fred Fennell and later William Fennell. The house that stands was located behind the tollbooth and was the home of Rev. James C. Carson. The word *turnpike* is derived from a pike being placed on the road at a tollhouse, which prevented a traveler from continuing on his journey until the toll was paid. (Courtesy of Bob Cupp.)

This is an example of the type of tolls that may have been paid at the tollgate. Rates depended on the number of items or animals being transported and the size of the vehicle. Much of the revenue that was collected at the tollgate went toward maintenance of the dirt-and-stone road. (Courtesy of Tracy Searight.)

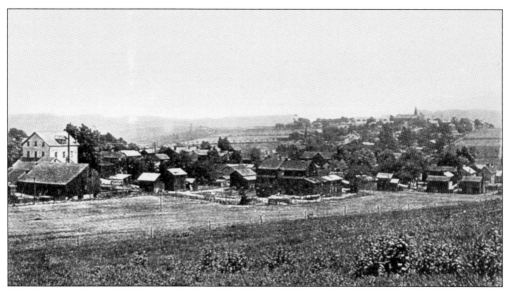

This is a view from the top of a hill on the southwest part of town in 1913. Once a booming stagecoach stop just 30 miles from Pittsburgh, Salem Crossroads, in Westmoreland County, was becoming a quiet town. (Courtesy of Bob Cupp.)

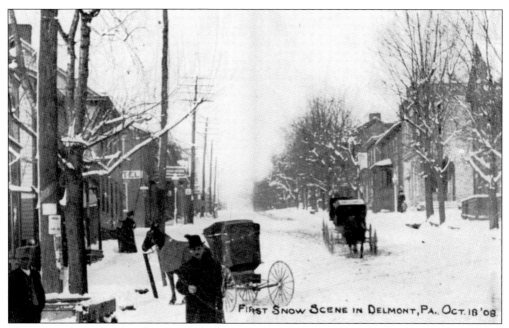

The original crossroads village included East Pittsburgh Street in Delmont. In 1908, during an early snowfall in October, residents are out and about, even on such a cold day. On the right side of the photograph is Delmont's First National Bank building. In the 1930s, it was moved back to make room for Freedom Oil Company pumps. The bank closed its doors two years after this photograph was taken. (Courtesy of Charles A. Hall.)

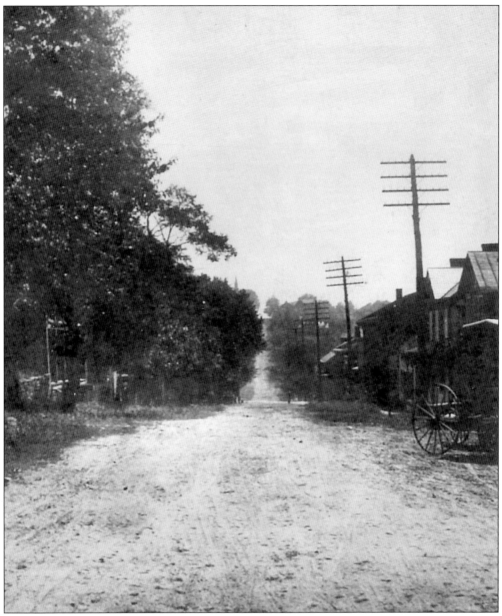

Salem Crossroads (now Delmont) flourished as a busy stagecoach stop owing to its location on the route of the Northern Turnpike. In the center left background of this photograph is the steeple of the New Salem Lutheran Church. (Courtesy of Robert Z. Yaley.)

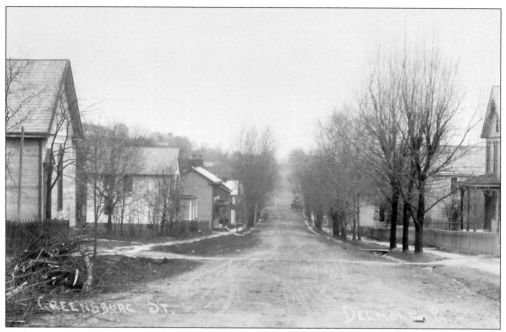

Today, it is known as Greensburg Street, but in the early days this street was known as the Greensburg-Kittanning Pike. This was a dirt road prior to the 1920s. To the left of the photograph, just out of view, was the Methodist church, which burned down in 1898. Across the street just out of view was the Delmont School. (Courtesy of Robert Z. Yaley.)

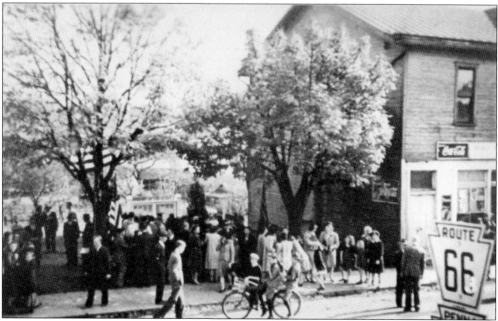

Residents of Delmont always enjoyed various community activities. On Route 66 (now Greensburg Street), a crowd gathers to unveil a new memorial for members of the community who served in the military. The memorial, which no longer stands in Delmont, included the title "Our Boys That Served." (Courtesy of Delmont Borough.)

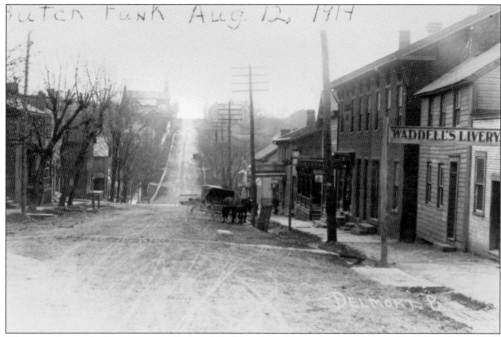

The town boasted a busy stagecoach stop. The Northern Turnpike passed through Salem Crossroads (now Delmont) on an east-west route from Philadelphia to Pittsburgh. Originally, it was just a dirt path, its wagon ruts and holes filled in with stones. (Courtesy of Robert Z. Yaley.)

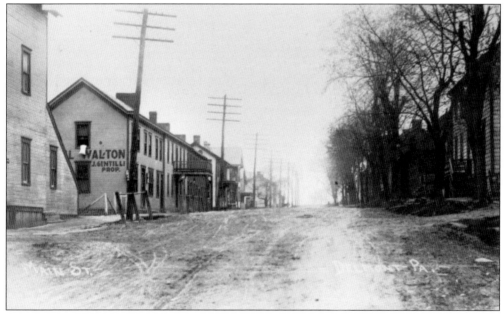

This is a postcard photograph of West Greensburg Street. On the left side of the photograph is the Walton Hotel. It was located adjacent to Shuster's Mill, which is now an Agway. The hotel was razed to make room for a new four-lane Route 66. (Courtesy of Tracy Searight.)

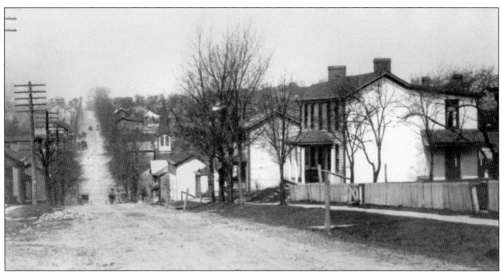

The last stop before Pittsburgh, West Pittsburgh Street had been an active stagecoach stop. But the busy stagecoach center eventually became a quiet village. The railroad to western Pennsylvania bypassed Salem Crossroads, leaving little need for stagecoaches. The Pennsylvania Railroad built spur tracks to the coal-mining communities to haul coal to large commercial centers like the steel mills in Pittsburgh. Despite being excluded from the growth and financial gain that sprouted up in the surrounding region, Salem Crossroads survived. (Courtesy of Leslie Tsouris.)

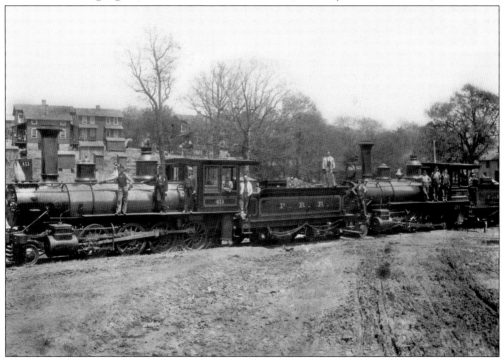

Coal was the primary freight being hauled on the rail line that passed just north of Delmont. The railroad made the development of Pennsylvania industry possible. The train passed by several small mining communities along the route. The Turtle Creek Valley branch of the Pennsylvania Railroad is seen in this 1918 photograph. (Courtesy of Bob Cupp.)

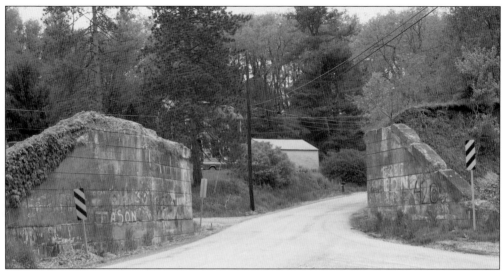

The abundance of coal in Salem Township led to a demand for railroad service. In December 1887, near Trees Mills, heavy blazing and grading for a railroad commenced. In early 1890, with surveys having been made, railroad engineers were busy locating a branch line from Manor to Apollo via Delmont. The burned cabins located north of Delmont that had been used for the railroad workers were selected as the railroad terminus in 1917. In the summer of 1919, the railroad was to be built to Saltsburg. In March of that year, it reached Cambria (or Slickville, as it was beginning to be called), six miles from Delmont. (Courtesy of Bob Cupp.)

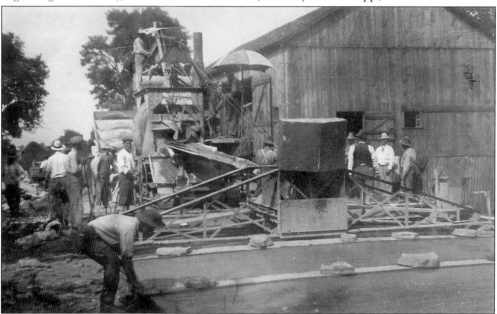

Around 1800, the north-south road from Poke Run Church to Greensburg, known as the Greensburg-Kittanning Pike, and later the Greensburg Road, was built through Salem Crossroads. The route became Pennsylvania Route 69 and the present-day Route 66. This photograph shows men at work on the construction of the north-south road between Delmont and Greensburg. The road construction passed through Samuel E. Black's farm, which was located two miles south of Delmont, near the current location of the Old Route 66 Grille. (Courtesy of Robert Z. Yaley.)

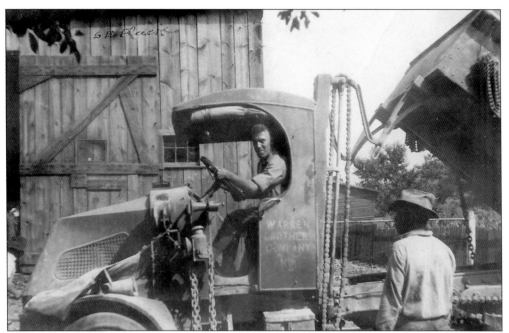

The initial paving of the new Route 66 was a huge undertaking. Here, the Warren Brothers Company provides an early dump truck. (Courtesy of Robert Z. Yaley.)

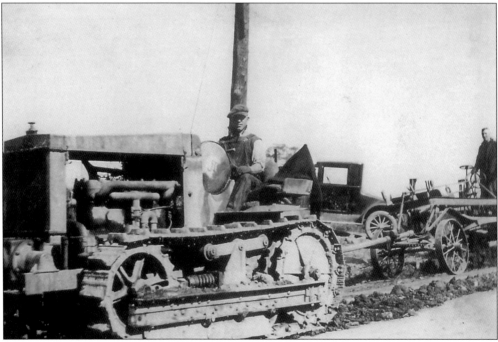

The original William Penn Highway Paving project spanned many years. The grading from Export to Delmont was completed in October 1922; in 1924, the Delmont to New Alexandria section was paved. It was not until 1949 that the new highway was completed from Murrysville through the Delmont area. Delmont suffered when, over time, the east-west road was relocated about a mile south. (Courtesy Robert. Z. Yaley.)

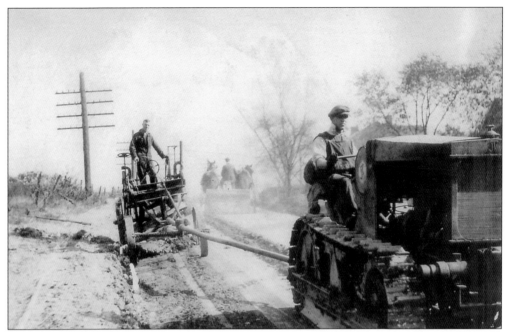

Today's road construction looks very different from the techniques shown in this photograph, taken east of Delmont during the construction of the Old William Penn Highway. (Courtesy of Robert Z. Yaley.)

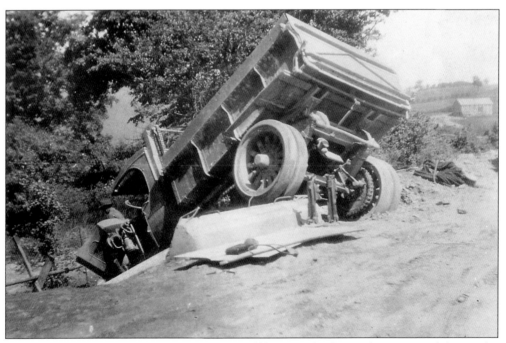

Even though workers were careful, accidents still happened. This mishap occurred during the initial paving of what would later be known as Route 66 just north of Delmont near the C.M. Hall farm. (Courtesy of Robert Z. Yaley.)

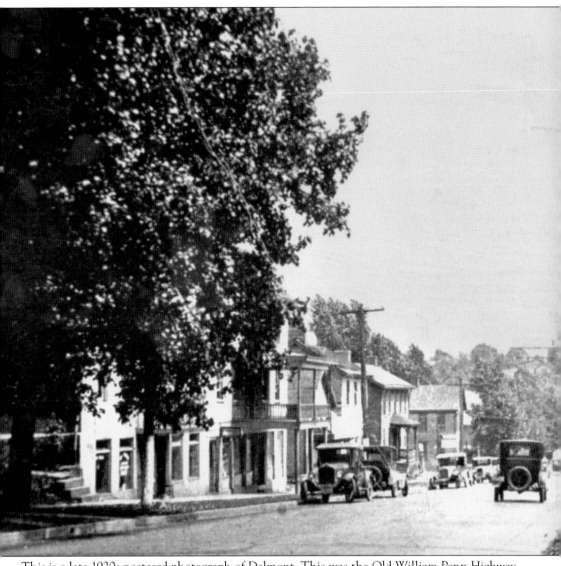

This is a late-1920s postcard photograph of Delmont. This was the Old William Penn Highway that followed the route of the Northern Turnpike that ran through Salem Crossroads (Delmont), Export, and Murrysville. (Courtesy of Raymond Meehan.)

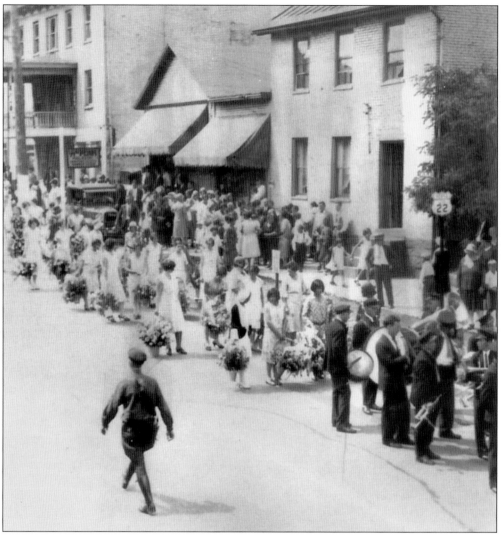

In this photograph, the residents of Delmont are waiting for the beginning of a parade on US Route 22 (present-day Freeport Street). This street continues to the intersection until it passes the old Central Hotel, where the road becomes Greensburg Street. (Courtesy of Lysle Bash.)

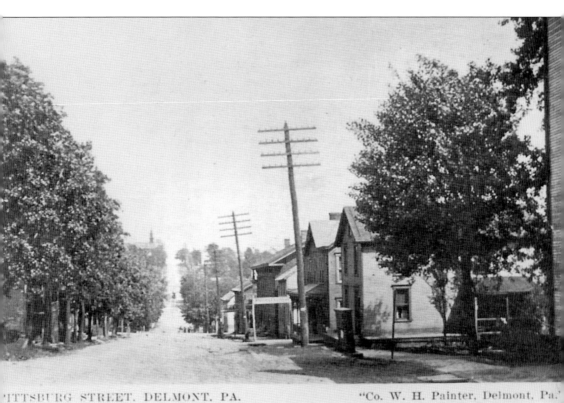

PITTSBURG STREET. DELMONT. PA. "Co. W. H. Painter, Delmont, Pa."

Besides the confusion caused by the town and post office changing names and coexisting under different names, the streets of Delmont had many names over the years as well. This postcard from "Co. W.H. Painter, Delmont, Pa." documents the road as Pittsburg Street, but it was originally known as Main Street. Two main roadways weaved their way through New Salem: the Old William Penn Highway and the Greensburg-Kittanning Pike. The Old William Penn Highway was formerly known as the Northern Pike. Construction began in 1818, and it was opened for travel in 1819. Stagecoaches ran between Pittsburgh and Philadelphia until 1853, when the Pennsylvania Railroad was completed. It was decided in 1916, almost 100 years later, that the William Penn Highway would follow the old Northern Pike. (Courtesy of Bob Cupp.)

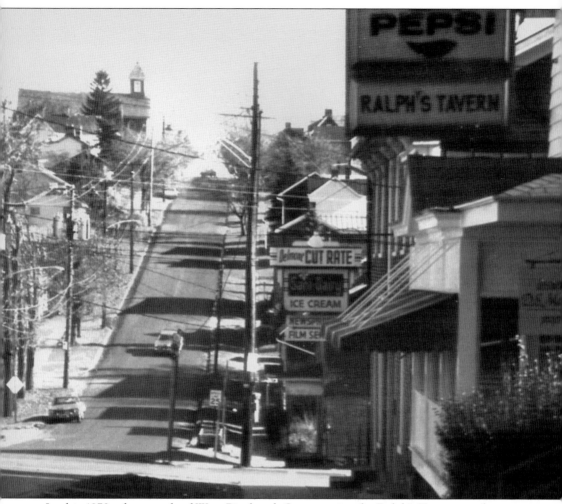

In this 1970s photograph of West Pittsburgh Street, a sign for Ralph's Tavern can be seen on the right. This was the location of Zachariah Zimmerman's drugstore. On the right just behind the speed limit sign is the water trough. Salem Lutheran Church (Salem Evangelical Lutheran Church) is on the left at the top of the hill. (Courtesy of Leslie Tsouris.)

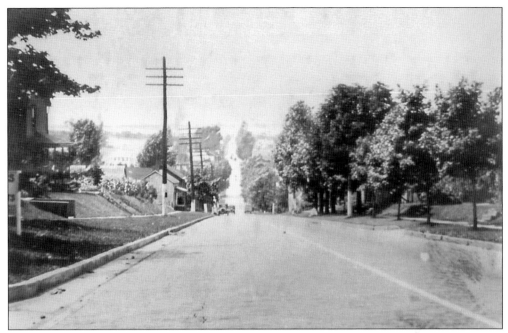

This photograph shows the old William Penn Highway that runs straight into Export. The view was taken looking from the road that the locals nicknamed "Lutheran Hill" after Salem Lutheran Church (Salem Evangelical Lutheran Church). The passage was a dirt road until the 1920s, when the William Penn Highway was completed. In time, due to traffic congestion, a new William Penn Highway (US Route 22) was built. (Courtesy Robert Z. Yaley.)

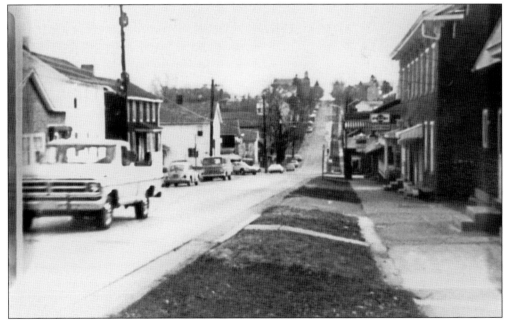

In 1972, to preserve the history of Delmont, the Salem Crossroads Historical Restoration Society was organized. This photograph of West Pittsburgh Street is from 1972, when the society began planning restoration projects in Delmont. (Courtesy of Leslie Tsouris.)

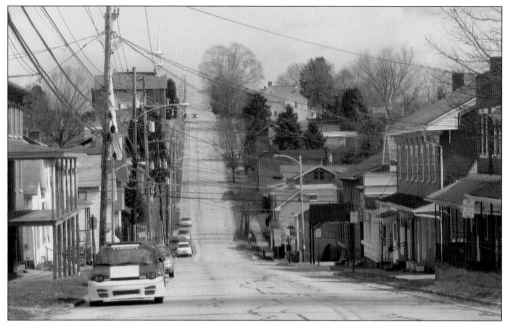

Before it disbanded, the Salem Crossroads Historical Restoration Society made efforts in the community to preserve Delmont. In 1978, the National Register of Historic Places added the Salem Crossroads Historic District to it list. The site, along Pittsburgh and Greensburg Streets, encompasses 200 acres and 64 buildings. Delmont has changed very little since this 2008 picture of West Pittsburgh Street was taken. (Courtesy of Bob Cupp.)

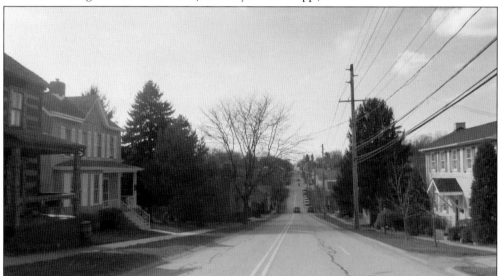

Standing on East Pittsburgh Street, one can imagine a stagecoach traveling down the dirt road, on its way to the tollhouse. A line of stagecoaches traveled along this road, once known as the Northern Turnpike. The crossroads community was the last stop along the Northern Turnpike from Philadelphia to Pittsburgh. The stagecoaches traveled over the rolling hills into New Salem (Delmont). Passengers would stop at the crossroads town to enjoy a hot meal and spend the night before heading out the next day on the 23-mile journey to Pittsburgh. (Courtesy of Tracy Searight.)

On April 5, 1999, construction began on transforming the interchange at US 22 and Pennsylvania Turnpike 66 from a cloverleaf into a SPDI (Single Point Diamond Interchange). (Courtesy of Mackin Engineering Co.)

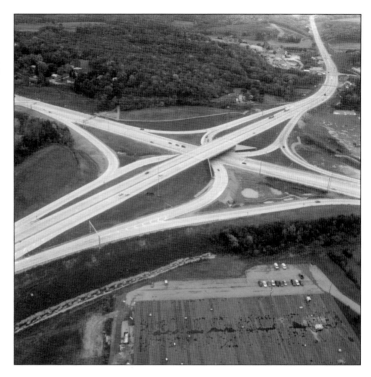

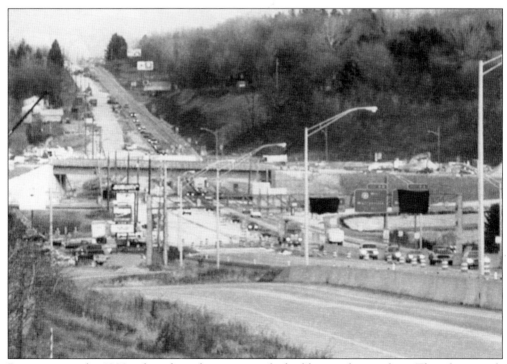

Beginning in the 1990s, there have been times of rebuilding and upgrading. This photograph shows construction on US Route 66. (Courtesy of Raymond Meehan.)

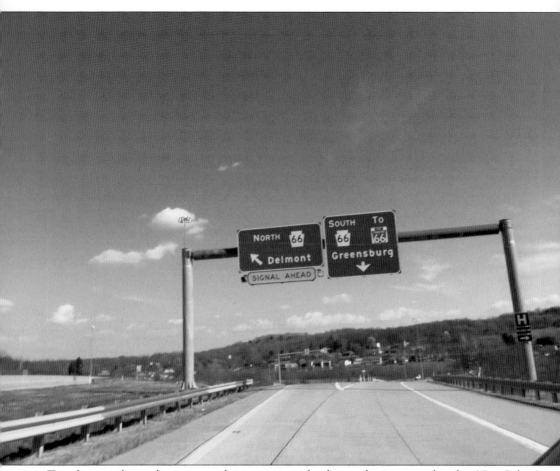

Traveling conditions have come a long way since the dirt roads visitors endured in New Salem's early days. Today's travelers take an exit off of Route 22 to reach Delmont via Route 66. (Courtesy of Tracy Searight.)

Six

OLD MEETS NEW

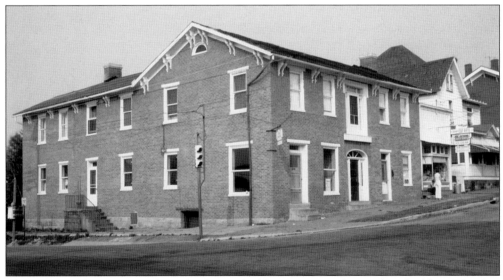

Built in 1814, this is New Salem's (Delmont's) oldest continuously standing building. The first owner of this structure was Robert Black, and several others followed over time. The hotel became one of the leading establishments along the Northern Pike due to New Salem's status as the last stagecoach stop before Pittsburgh. At the rear of the building was a barn that kept horses to allow stagecoach drivers to get a fresh team. The barn was destroyed in a fire in the 1950s. (Courtesy of Fred Yenerall.)

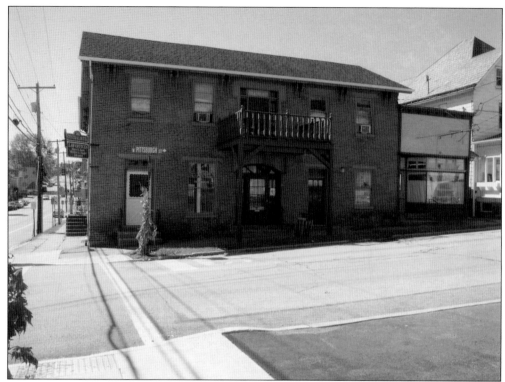

Over the years, the building has had a long list of owners. One that stands out is Thomas L. Wilson, who bought the property from a Mr. Lauffer in 1906. At that time, the only carbon streetlamp in the town hung outside of the building on the corner. (Courtesy of Tracy Searight.)

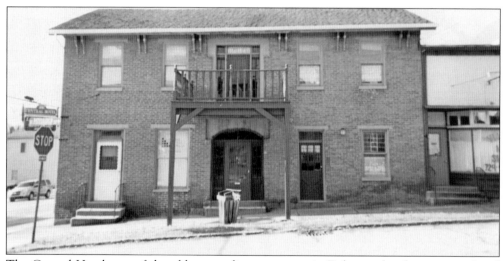

The Central Hotel, one of the oldest standing structures in Delmont, has been restored and remains a commercial property. The present owner is Ross S. Bash, who maintains a law office in the building. (Courtesy of Tracy Searight.)

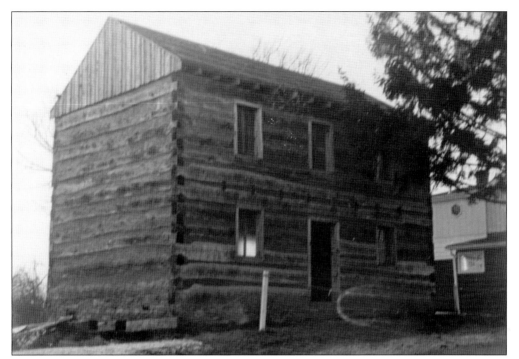

This log house is located on East Pittsburgh Street, across from the Salem Lutheran Evangelical Church. During the late 1970s, Delmont began a major restoration effort to preserve the historic architecture of the house. (Courtesy of Delmont Borough.)

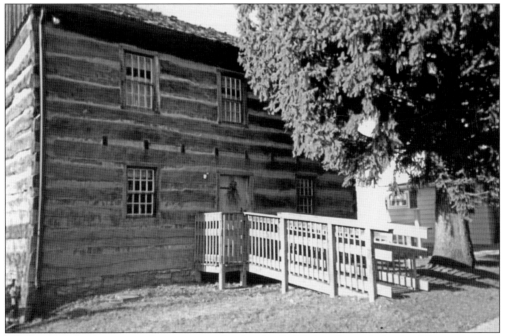

The log cabin serves as a welcome center for the Apple 'N Arts festival. A wheelchair ramp was built for the front and back entrances to allow guests access and to rent wheelchairs for the event. The building also stores a few historic pieces. (Courtesy of Tracy Searight.)

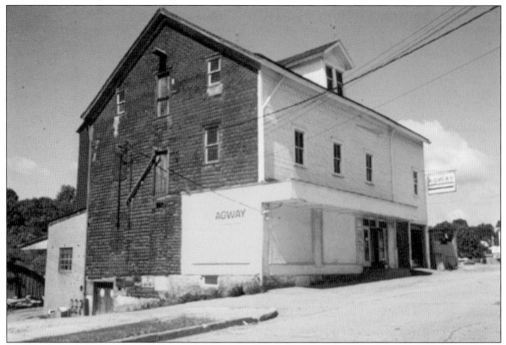

The building in this photograph, once Shuster's Mill, is now the Agway store. In 1958, the building was almost torn down to make room for the new four-lane Route 66 that was being constructed just to the west. During the 1960s, the Delmont Farmers Bureau became the Agway store. This photograph shows the store as it appeared in 1974. (Courtesy of Fred Yenerall.)

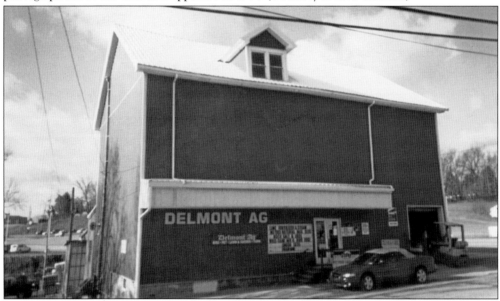

Marshall Hoffman, a longtime Agway employee, came to the rescue when the decision was made to close the store in 1986. Hoffman purchase it from Agway and operated the independent Delmont Agway for 20 years until his retirement. This is thee Delmont Agway on West Pittsburgh Street as it stands today. It sells a variety of supplies such as garden tools, grass seeds, and flowers. The store provides a hometown alternative to the big-name garden stores. (Courtesy Tracy Searight.)

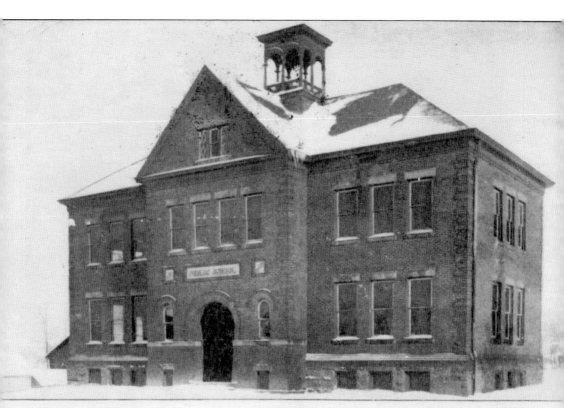

School Building, Delmont, Pa. Annie M. Carothers, Publis

In 1833, after New Salem was incorporated, the size of the district was restricted to include Salem Township within one mile of the center of New Salem. In 1836, a piece of land was purchased on the existing school site. The demand for better facilities led to the razing of the one-story structure, and a two-story, two-room building was erected. In 1898, the building was deemed unsafe and was torn down. Its replacement is the structure that stands on Greensburg Street today. The contractor was G.W. Shaw, and the cost of the building, including furnishings, came to $19,000. (Courtesy of Arthur F. Humphrey III.)

97

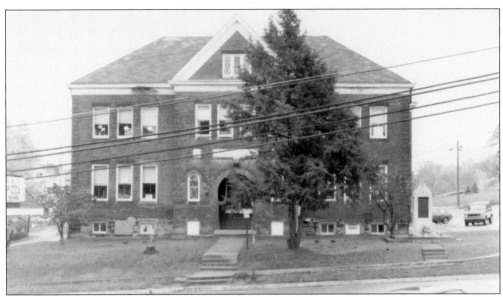

By the late 1940s, the junior high program at the school had ended. Students either went to Greensburg or Franklin for their final two years of high school. Tuition was based on whether one lived in the borough or in Salem Township. The building continued to serve as a grade school until it closed in 1983. The Delmont Borough then acquired the property. (Courtesy of Faith United Methodist Church.)

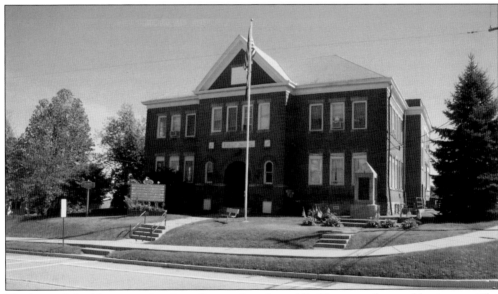

The borough building contains the police station, the public library, and several businesses. The police station occupies the former school kitchen, and the old teachers' lounge is now the police department's exercise room. The library moved into the building in the mid-1980s. It hosts several children's programs during the summer and story times and holiday activities throughout the year. On the building's top floor, five former classrooms are occupied by Salem Crossroads Daycare, which offers infant care and preschool education, as well as before-school and after-school services for school-age children. Shirley Frye ran the day care for several years until she retired and sold the business in 2010. (Courtesy of Tracy Searight.)

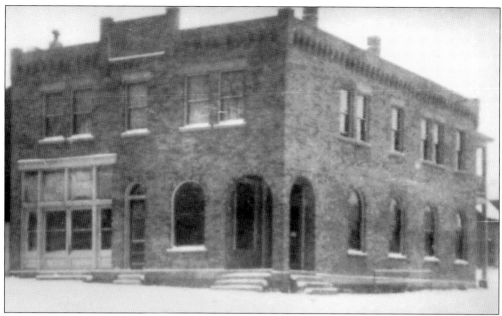

The First National Bank of Delmont opened for business in January 1902 with $25,000 in capital. It was located at what is now the corner of West Pittsburgh and Freeport Streets, across from the Central Hotel. Local attorney Joseph McQuaide was the bank's first president, and James E. Douglas was vice president. The two-story brick building cost less than $20,000 to build; a burglarproof safe and vault cost an additional $3,500. The bank closed on May 2, 1906, amid charges of embezzlement. (Courtesy of Robert Z. Yaley.)

After Delmont's First National Bank closed its doors on West Pittsburgh Street, another business, Cohen's Department Store, occupied the building. Cohen's sold a variety of items. Standing outside the store in this 1921 photograph are Dorothy Zimmerman, her niece Eleanor, and her nephew Jimmy Zimmerman. (Courtesy of Robert Z. Yaley.)

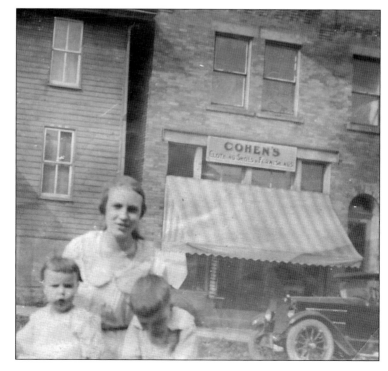

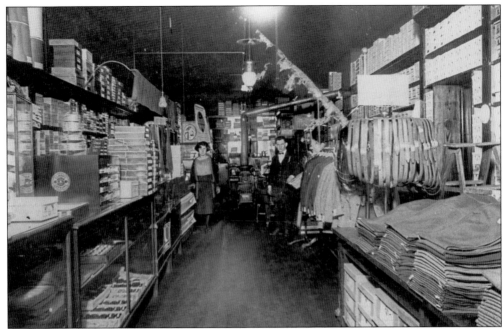

This is a photograph of the inside of the West Pittsburgh Street building in 1925. At that time, Cohen's Department Store sold clothes, shoes, and furnishings to the residents of Delmont. The department store eventually moved to Export by the 1930s. (Courtesy of Raymond Meehan.)

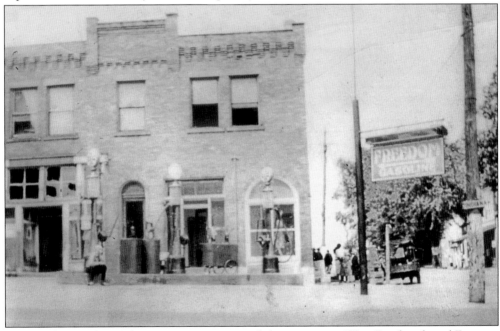

In 1930, the Freedom Oil service station occupied the property at West Pittsburgh and Freeport Streets. Aleck Mitchell, the owner, installed gas pumps in front. In order to make room for the pumps, the structure, along with its basement, was moved back from the street. A Pittsburgh firm that specialized in moving large buildings was called in to do the job, which involved jacking up the foundation and rolling it back several feet. (Courtesy of Robert Z. Yaley.)

A hardware store occupied the entire structure until Dell Shearer inherited the building from his father, H.M. Shearer. Raymond Mook continued to rent the building from Dell Shearer until 1957, when Mook passed away. His sons Paul and John took over the business and, 20 years later, John Mook purchased the property from Dell Shearer. The Mook family operated Delmont Plumbing and Hardware in this location from 1952 until 1989. John Mook sold the store in 1989, but continued to work with the owners until 1992. The hardware business closed for good in 1995. (Courtesy of Lysle Bash.)

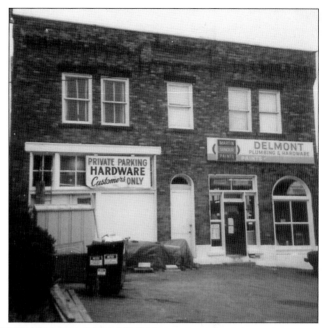

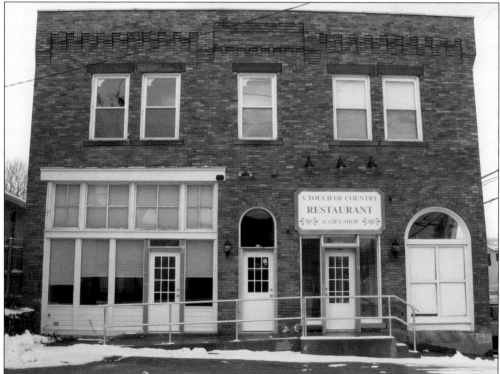

When the hardware store closed in 1995, Sandy Alexander, who lived in Murrysville, bought the building and opened a restaurant and gift shop, A Touch of Country. She made home-cooked meals and sold a variety of handcrafted gifts and collectables. Delmont resident Kevin Dibert recalls, "she made the best pancakes I ever tasted." Alexander continued her business for the next decade, retiring in 2005. The property sat vacant for the next two years. (Courtesy of Bob Cupp.)

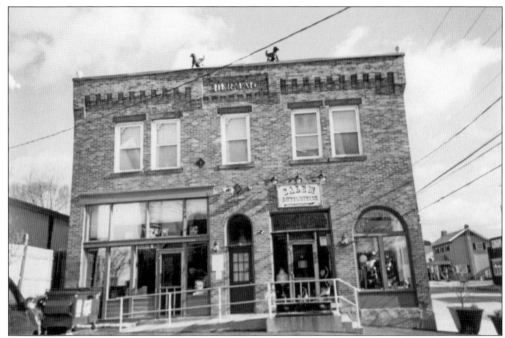

This building has had many lives. It started out as a bank, then operated as a department store, gas station, hardware store, and restaurant. In 2007, Trees Mills resident Melissa Herman purchased and restored the property to open Salem Antiquities, which sells "antique vintage curiosities, international treasures, and stuff." (Courtesy of Tracy Searight.)

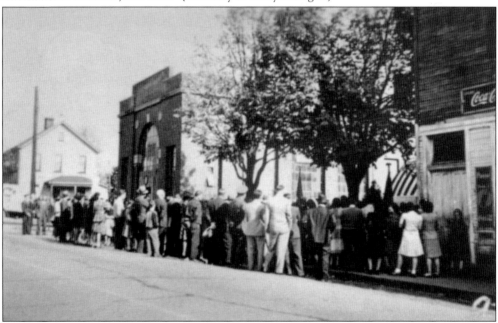

In August 1926, construction began on the People's National Bank on the corner of present-day Greensburg and East Pittsburgh Streets. The 50-by-30-foot building was completed by March 1927. The bank prospered until 1929, when the stock market crashed. In October 1930, heavy withdrawals began, and the bank closed it doors on June 4, 1931. (Courtesy of Robert Z. Yaley.)

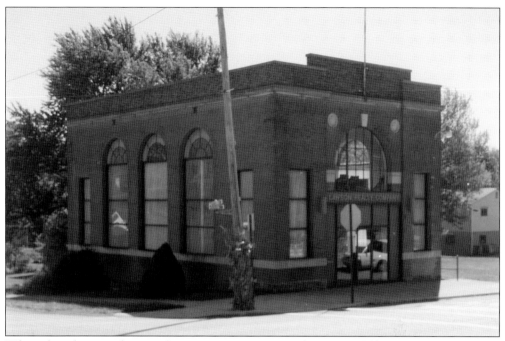

When this photograph was taken in 2008, Lawson Realty was in full swing in the old bank building. At that time, the bank's safe was still there, in the same condition as it was in 1931. (Courtesy of Bob Cupp.)

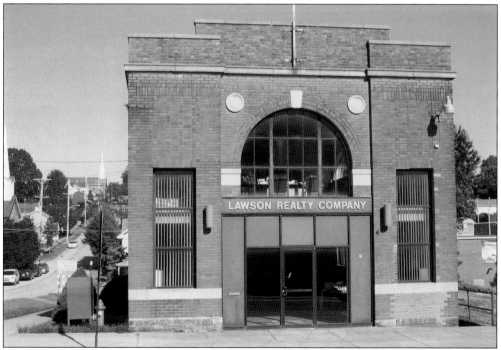

The property's latest tenant had been a real estate agency, but in 2011, the building went up for sale. Despite the recent removal of the sale sign, the structure remains empty—except for furniture left by Lawson Realty. (Courtesy of Tracy Searight.)

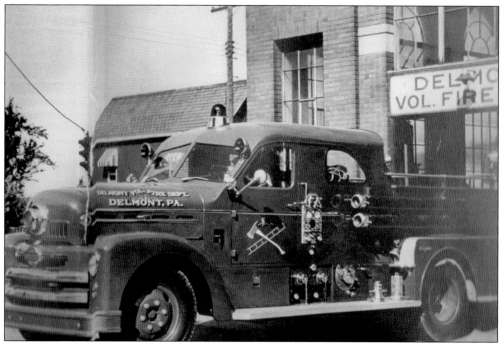

The old bank building was also occupied for decades by the Delmont Volunteer Fire Department. In this photograph, the department's fire truck is parked in the entrance. (Courtesy of World Class Transmission.)

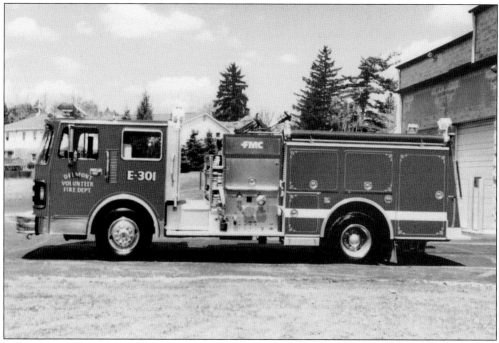

Today, the Delmont volunteer fire company's truck looks very different from the ones used years ago. The fire department is now located off of Route 66 in the VFW Building. (Courtesy of the Delmont Fire Department.)

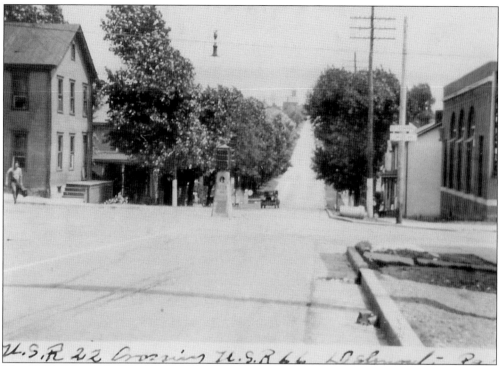

The William Penn Highway, linking Pittsburgh with Philadelphia, was completed in 1819. This postcard shows the crossing of US Route 22 with US Route 66. This location is where Greensburg, Freeport, and Pittsburgh Streets now meet. In the center of the crossroads is a traffic dummy that, years later, was found and restored by the Salem Crossroads Historical Society. (Courtesy of Tracy Searight.)

This is the traffic dummy that was located on Old Route 22, present-day East Pittsburgh Street. It had been lost, but was later found thrown over a hill. Having been restored, the dummy now sits in a park next to the home on Greensburg Street that was owned by Jacob Earnest prior to his death in 1884. At one time, Earnest had his gunsmith shop on the property as well. The park consists of a wishing well, the traffic dummy, and a bench. (Courtesy of Bob Cupp.)

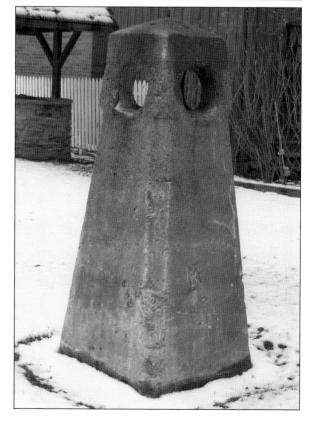

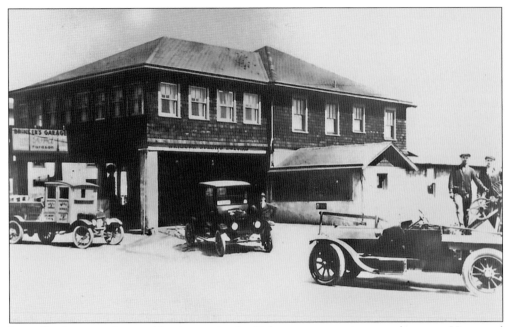

Jessie Brinker owned several businesses in the Delmont community over the years. He owned this building on Manor Road and ran Brinker's Auto Service Station. During the 1930s, Brinker also owned a motel called Delmont Gardens, which would eventually relocate as Villa D'Esta. (Courtesy of Tracy Searight.)

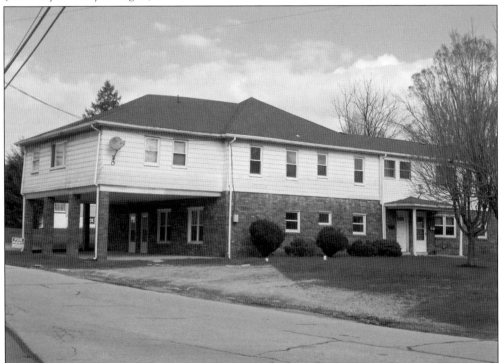

The former Brinker Auto Service and Villa D'Esta on Manor Drive is now a rental property with apartments. (Courtesy of Tracy Searight.)

In 1950, Jessie Brinker built a new Villa D'Esta south of Delmont along what is now Route 66 (Sheridan Road). During that time, Villa D'Esta served as hotel and restaurant. Rooms were $10 and up a week, and the restaurant included a dairy bar and curb service. (Courtesy of World Class Transmission.)

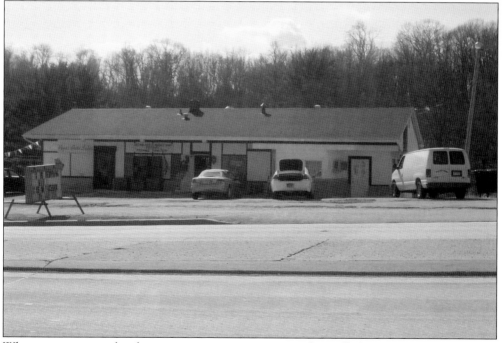

What was once a motel and restaurant is now a consignment shop called Second Fiddle, specializing in unique finds. (Courtesy of Tracy Searight.)

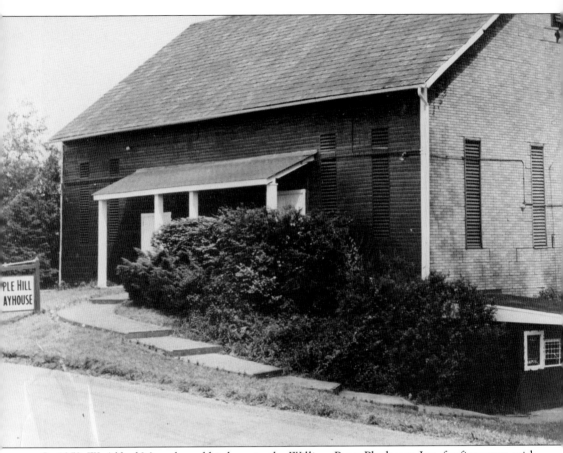

In 1952, W. Alfred Martz leased his barn to the William Penn Playhouse Inc. for five years, with the option to buy the property. The renovated barn near the old Villa D'Esta has become the leading summer theater in western Pennsylvania. The playhouse association purchased the barn in 1957 prior to Martz's death on April 11, 1957. (Courtesy of Apple Hill Playhouse.)

The Apple Hill Playhouse Theatre on Manor Road boasts "the best little theatre in the country." Apple Hill Playhouse is one of the oldest working theater barns in western Pennsylvania. Apple Hill performs several plays during the year and offers dinner theater with the Lamplighter. Apple Hill Playhouse also offers a Johnny Appleseed Children's Theatre that performs productions and offers performance camps during the summer. (Courtesy of Tracy Searight.)

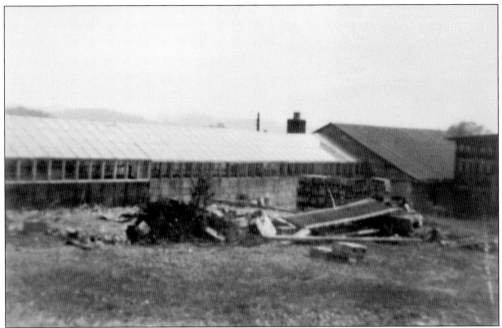

This 1963 photograph shows the building that was located on the property of Everett Plowman. It is hard to believe that, years later, this location would be a community park. (Courtesy of Delmont Borough.)

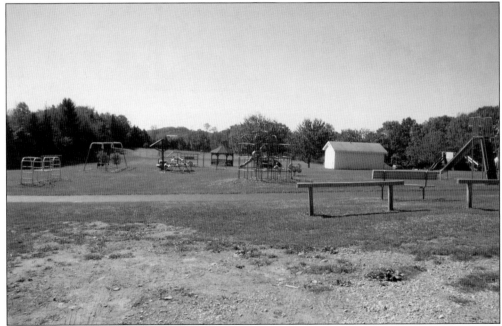

In 1963, money given by George Newhouse was used to purchase the Everett Plowman property. The land now functions as a park for the community. It includes a baseball field, small trail, playground, and pavilion. The Delmont recreation department hosts Movies in the Park and the an annual Easter egg hunt. The pavilion is also used for family events and birthdays. (Courtesy of Tracy Searight.)

Seven

SHIELDS'S GIFT

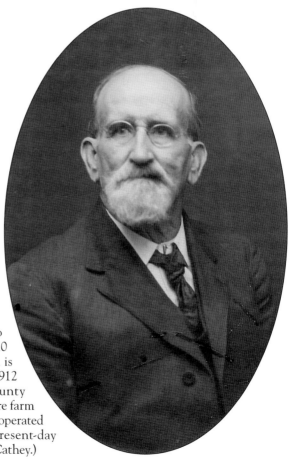

This photograph shows Samuel Shields, the son of Robert Shields. Samuel, who married Mary Jackson, is listed in the 1910 Delmont census, where his occupation is given as "farmer—working out." A 1912 property map of Westmoreland County shows that "Sam Shields" owns a 160-acre farm in Delmont. Prior to the Civil War, he operated a grocery and mercantile store on present-day Greensburg Street. (Courtesy of Alice Cathey.)

Samuel and Mary Shields had a son named Robert "R.J." Shields. This is R.J. Shields as a child in 1870. He would grow up to become a well-known and respected teacher, eventually becoming principal of the Delmont School. (Courtesy of Alice Cathey.)

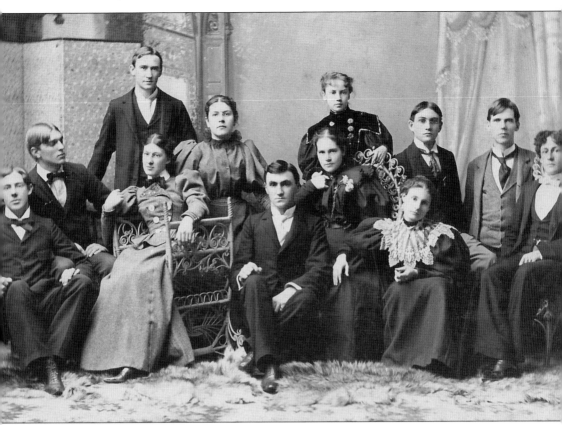

This 1880s photograph shows Robert Jackson "R.J." Shields (third from left, standing) as a college senior at the Central State Normal School in Lock Haven (now Lock Haven University). He entered the teaching field and became principal of the Delmont School. Shields never married, but at age 50 in 1920, he assumed responsibility for raising his niece and nephew (Marjorie, 14, and Fred Shields, 5) after his sister Annamary Madge Shields Ewing died suddenly. Her husband, John Ewing, had passed away two years prior. R.J. and the Ewing children lived in the log cabin on East Pittsburgh Street where Shields once operated his tannery. (Courtesy of Alice Cathey.)

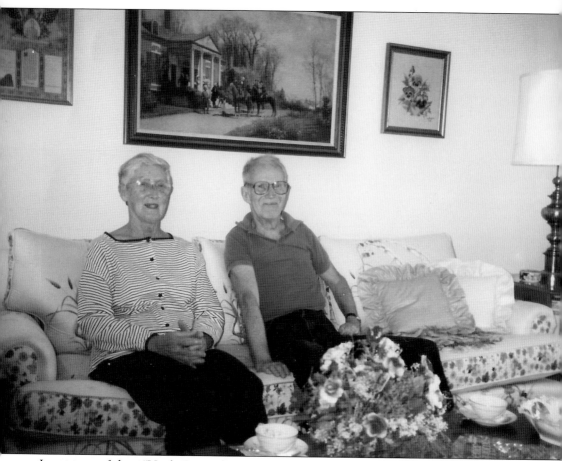

In memory of their "Uncle Bert," the two children that R.J. Shields helped raise, Fred Shields Ewing of Delmont and his sister, Marjorie Ewing Snyder of Baltimore, Maryland, (shown here in 1990) generously donated half of the $288,000 purchase price toward the acquisition of Shields Farm. The remaining funds were matched by a grant from the Pennsylvania Department of Community Affairs. (Courtesy of Alice Cathey.)

In 1980, the Shields Farm was acquired by Delmont, in conjunction with the Salem Crossroads Historical Restoration Society, from the Shields family. This is the tentative plan for the development and repurposing of the field. (Courtesy of Westmoreland Historical Society.)

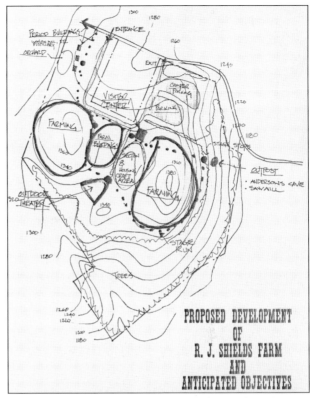

Shown here is the entrance to Shields Farm, the site of the Apple 'N Arts festival. The farm includes a trail and baseball field. (Courtesy of Tracy Searight.)

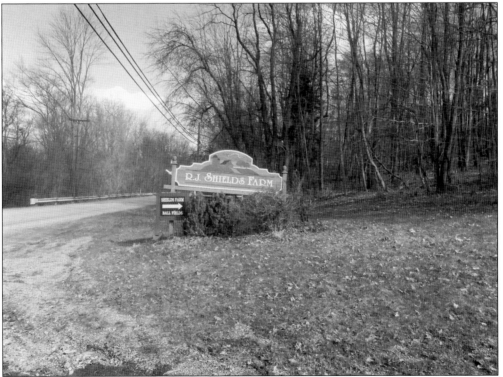

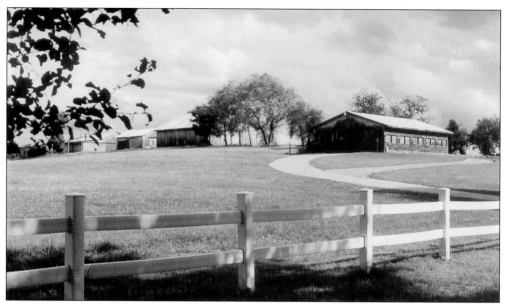

From 1927 until 1946, Shields Farm was a working farm occupied by tenant farmers Homer and Anna Cochran. The Cochrans operated Cochran Dairy during that time. In 1980, the 45-acre Shields Farm was acquired by Delmont in connection with the Salem Crossroads Historical Restoration Society. During the late 1830s, a former schoolteacher from Greensburg named Anderson would leap onto the back of stagecoaches and commit robberies. He hid his treasure in a cave on the Shields farm called Anderson's Cave. Anderson was finally captured and sentenced, but he died 50 days later from refusal of food and water. (Courtesy of Bob Cupp.)

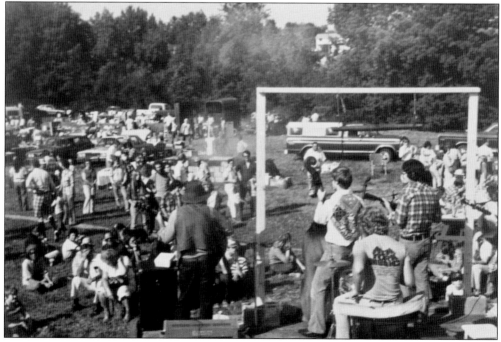

The Apple 'N Arts festival debuted in 1986. Initially occupying a small venue, the festival grew over the years and today welcomes 30,000–40,000 visitors annually. (Courtesy of Delmont Borough.)

During the early part of the 20th century, Shields Farm was a working farm and was occupied by tenant farmers. Homer and Anna Cochran rented the property from 1927 to 1946 and lived in the Shields farmhouse. The farmhouse is located on East Pittsburgh Street and is now occupied by the Salvation Army. (Courtesy of Tracy Searight.)

There are several wooden barns on Shields Farm that the borough uses for the Apple 'N Arts festival. Prior to the donation of Shields Farm, the land was leased out for personal use. (Courtesy of Tracy Searight.)

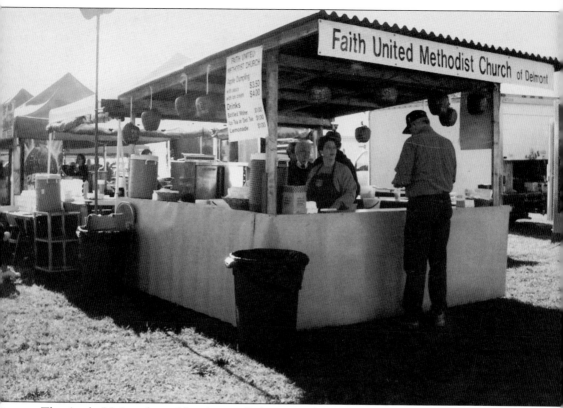

The Apple 'N Arts festival has been a Delmont tradition for more than 26 years. The festival features more than 150 arts and craft vendors and 30 food vendors. On the first weekend in October, visitors enjoy two days' worth of fun-filled events, including an old-fashioned hayride. Other activities include the Baby Apple Cheeks petting zoo, demonstrations of antique gas engines, balers, an operating sawmill, and Ye Olde Shingle Mill music. A nondenominational worship service is held on Sunday. Several local churches, including Faith United Methodist, have booths during the festival. (Courtesy of Faith United Methodist Church.)

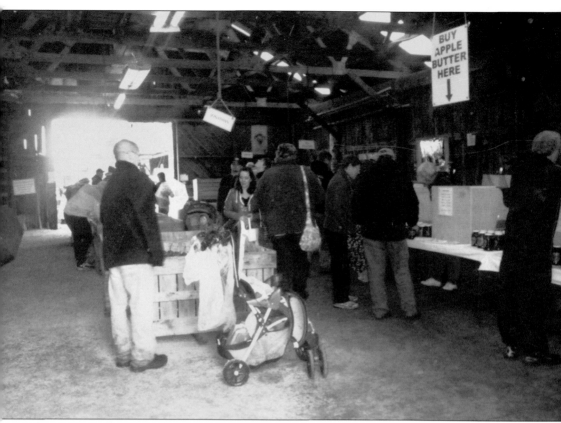

This is a typical scene at the Apple 'N Arts festival, held the first weekend in October. Each year, hundreds of vendors come to the farm to sell food, artworks, and crafts. This is a view inside the barn, where visitors can buy apples and where apple cider is made fresh using a 110-year-old cider press. (Courtesy of Brandy Walters.)

The gift of Fred Shields Ewing and his sister Marjorie Ewing Snyder continues to benefit the community, especially the children of Delmont. Shields Farm now has a baseball field that is used by the Delmont Baseball Association. (Courtesy of Chris Nicely.)

Eight

DELMONT CONTINUES ON

Christmas in Salem Crossroads

Delmont, Pennsylvania

Delmont hosts the Christmas in Salem Crossroads Pilgrimage every year during the first two weekends in December. The community reenacts the first Noel and visually transports the visitor to the Bethlehem of 2,000 years ago. The tour begins at the top of East Pittsburgh Street, then continues on carefully cleared paths on the old Shields Farm, and includes visits to Delmont churches. The churches on the tour include Salem Lutheran Church, Trinity United Church of Christ, Delmont Presbyterian Church, Faith United Methodist Church, and St. John Baptist de la Salle. (Courtesy of Faith United Methodist Church.)

Located on Freeport Street, this building was Moonis Meat Market, which sold meat and groceries from 1945 to 1987. It is now the wood-oven Ianni's Pizzeria. (Courtesy of Tracy Searight.)

During the construction and renovation of the property on 5 Freeport Street that brought about Ianni's Pizzeria, workers uncovered this old wooden cooler from Moonis Market. (Courtesy of Tracy Searight.)

Throughout Delmont, various enterprises make reference to either Salem or Salem Crossroads. On US Route 22, one example is Salem Plaza, pictured here, which contains several businesses and medical offices. (Courtesy Tracy Searight.)

At one time, this lot on Greensburg Street was the location of Jacob Earnest's gun shop. His home, built in 1827, is still in use today. Earnest deeded this lot to the town. The park created at the site includes the traffic dummy that once stood on old Route 22, a wishing well, and a bench. The wishing well was donated by the Delmont Women's Club. (Courtesy of Tracy Searight.)

On East Pittsburgh Street in Delmont, across from the Salem Evangelical Lutheran Church, is a log cabin. This log cabin was restored and is used during the Delmont Apple 'N Arts Festival and the Christmas in Salem Crossroads Pilgrimage. Buried on the ground of the log cabin is a time capsule that the now defunct Salem Crossroads Historical Society created for the future residents of Delmont to open in 2033. (Courtesy Tracy Searight.)

On Route 66 in both directions is a sign that welcomes residents and visitors to Delmont. The sign depicts a scene from the Christmas in Salem Crossroads Pilgrimage and includes the year of New Salem's incorporation, 1833. Although the town was known as New Salem, New Salem Borough, Salem X Roads (Salem Crossroads), and Delmont, the post office was the only establishment that carried the Delmont name from 1871 until 1967. In 1967, the town officially changed its name to Delmont to reflect what the post office had been using since 1871. (Courtesy of Tracy Searight.)

DISCOVER THOUSANDS OF LOCAL HISTORY BOOKS
FEATURING MILLIONS OF VINTAGE IMAGES

Arcadia Publishing, the leading local history publisher in the United States, is committed to making history accessible and meaningful through publishing books that celebrate and preserve the heritage of America's people and places.

Find more books like this at
www.arcadiapublishing.com

Search for your hometown history, your old stomping grounds, and even your favorite sports team.

Consistent with our mission to preserve history on a local level, this book was printed in South Carolina on American-made paper and manufactured entirely in the United States. Products carrying the accredited Forest Stewardship Council (FSC) label are printed on 100 percent FSC-certified paper.

MADE IN THE USA